Table of Contents

THE MYSTIC ART OF WRITTEN FORMS

An Illustrated Handbook for Lettering
By Friedrich Neugebauer

Translated by Bruce Kennett

NEUGEBAUER PRESS
Salzburg – London – Boston

Whence did
the colourous
mystic art arise,
of painting speech
and speaking to
the eyes?
That we
by tracing magic
lines, are taught
how to embody and
to colour thoughts.

William Massey

"Oh, Thou Great One, seen by (his) father,
Guardian of the Book of Thot. See, I come as a
spirit, a soul, a mighty one, provided with the
Scriptures of Thot. Hurry, Oh Aker, Thou who art
in the swamp, bring me the water bowl, the
palette, the writing tools of Thot, and the mysteries
dwelling therein."
Text from the 94th Chapter of the Egyptian Book
of the Dead, to be spoken by Nofretari.

"There is something still vibrating in these words;
a sense of the excitement that gripped man when
writing was first invented. This magic art of brush
and palette not only captures words but also
brings unspoken thoughts to life and thus preserves
them for all time. The inventor of this art was
Thot, the god of Wisdom and the Apocalypse.
In his roles as 'Re's Scribe' and 'Letter-writer
of the Ninefold,' he is the vizier who passes
sentence, evaluates laws, and decides in favor of
the person who does right."

E. Dondelinger, "Der Jenseitsweg der Nofretari, Die Heilige Schrift der Ägypter"
("Nofretari's Road to the Hereafter, The Holy Scriptures of the Egyptians")

The essence of anything unconsciously hidden becomes exposed and legible in writing—there is no chance for falsehood or disguise to go unnoticed. Personal lettering is the subtlest detector of one's substance and character; and lettering is the scribe's confession, the score composed of his states of being, his impulses and his emotions—all the things that move him at the moment of communication. The scribe is subject to a rhythm that comes from his pulse, from the movement of his blood. A special kind of cardiogram, flowing and ebbing, a translation of invisible mental states into the visible. Each movement is a spiritual act and finds its appropriate symbol. Thus is lettering: royal and humble, vulgar and noble, muddled or freely structured and self-evident. A grand procession of all human conditions, bound together by the rhythm of a significant act.

Writing is a cardiogram of one's character.

The person who concerns himself with lettering enters the realm of the earliest beginnings of human relations, their meaning, their formation. That is an important thing, and it justifies a life dedicated to lettering.

The ancient Chinese said: There are only three Arts: poetry, calligraphy and drawing. These are the arts which, through heart, brain and hand, and with a minimum of materials, achieve the highest level of intensity and clarity.

Anyone who moves in this circle, who joins the roaming of symbols and letters, is bound to himself, to his nature and to the values of his environment, good and bad, which he acknowledges and which move him. The acquired joins the innate. The scribe is defined by this; he is free and bound at the same time. A human who can only bring forth what lies within him, as a perceiver, as an instrument of his perceptions. No one can give more. It is a great deal. It is one of the accomplishments that man can bring about and make permanent by his own means and strengths.

Thus, a lettering artist lives today in a general evolution, an evolution that has been advanced throughout the ages by the practice of writing as a higher form of human expression. The possibilities reach from absorption in the word, from its fixation in lettering, from the shaping of an idea into words, from the inter-pretation of images, from the intensification of feelings, down a thousand steps to the muck of trashy literature. At the highest point he can attain he builds dams of spiritual form, there he pits design and selection against tumult and triviality. Here his work will be made secure by his nature, its lines and bounds, and the conditions that it imposes.

The duties of lettering

What distinguishes this person is his or her obligation to a duty that strives for organic order: LETTERING IS ORDER; IT IS THE MEANS TO A HIGHER CONSCIOUSNESS.

ΜΕ
ΕΤΗΝΔΙΟΒΕΛΙΑΙ
ΕΝΕΛΕΥΣΕΙΝΙΑΛΛΕΙΣΙΝΑΤΕΛΕΙ ΙΧΟΥ
ΕΙΝΙΕΝΤΗΑΓΟΡΑΠΙΠΡΑΣΚΩΣΙΝΟΣΜΕ
ΙΣΑΓΩΠΑΟΦΕΛΟΣΕΙΣΜΕΓΑΠΑΠΑΝΤΗΣΗ
ΑΠΟΥΣΠΑΛΙΝΚΑΠΗΛΕΥΟΝΤΑΣΠΕΠΑΥ
ΟΥΛΟΜΑΙΗΣΝΔΕΙΞΙΝΑΥΤΟΝΓΕΙΝΕΣΘΑΙ
ΕΓΟΥΣΙΑΓΟΥΒΟΥΛΗΣΤΟΝΔΕΕΙΣΑΓΕΙΝΕΙΣ
ΤΕΙΛΑΝΟΤΙΧΡΗΠΑΘΕΙΝΗΑΠΟΤΕΙΣΑΙΠΙΠΡΑΣ
ΚΟΜΙΖΟΝΤΕΣΗΟΙΠΡΩΤΟΙΠΑΡΑΥΤΩΝΟΝΩΝΟΥ
ΝΗΤΑΣΓΕΙΝΟΜΕΝΟΥΣΤΟΝΑΥΤΩΝΩΝΙΩΝΜ
ΤΑΣΤΕΙΜΑΣΤΑΥΤΗΝΤΗΝΕΠΙΣΤΟΛΗΝΣΤΗΛ
ΣΤΗΣΛΑΤΕΠΡΟΤΟΥΔΕΙΓΜΑΤΟΣ

ΕΠΙΜΕΛΗΤΕΥΣΙΤΟΣΤΗΣΠΟΛΕΟΣΤΙΟΥΛΙΟΥΗΡΩΛ

Writing is a system of human communication that works through the use of visible signs. The beginnings of writing are inseparably connected to those of art, and one must never treat them as two different entities.

All letters are signs, and all signs began as pictures. Any time that we use the signs of the alphabet, we are really relying on the past. The alphabet is the source. Its ancestors range from the cuneiform symbols of the Babylonian builders, through the hieroglyphs of the Egyptians, and on to the Greeks, who succeeded in combining vowels with the 22 consonants that had been in use up to that time. This discovery was really the seed from which Western thought grew and developed over the ensuing centuries.

The Romans brought the alphabet to completion. Around the middle of the first century A.D. they began to appreciate letters in a new way; alongside the traditional aspects of communication and expression, the aesthetic possibilities of letterforms sprang up. Inscriptions became a decorative element in the street, whether painted freely on walls or cut into stone; book pages became works of art.

When one considers the immense power of man's spirit, it is amazing to think that it could not have developed without the alphabet. How clearly we are heirs to this process . . . the links in a chain.

Runes are also at the root of Western writing, though it is still unclear whether they were developed solely by Germanic peoples. The Cyrillic alphabet (Glagolitza, Kyrillitza) grew out of the Greek majuscule letters and was later simplified into a "common script" by Peter the Great at the beginning of the 18th century. Numerals as we know them today were not a natural outgrowth of our own culture: they were borrowed around 1500 A.D. from the Arabs, who had in their turn developed them from the counting symbols of Indian Brahmin script. Up to that time, people within the spheres of influence of Semitic and Greek alphabets had written Roman numerals. The earliest known incidence of Indian numerals in Europe is on a Sicilian coin from 1138 A.D.

The educated class in China, more than in any other culture, has a clear and spiritual understanding of writing. Even in modern China, written characters are still valued and felt to be living expressions of graphic art. The cultured Chinese feel a divine mystery pulsating within the powerful beauty of these strokes, and consider calligraphy to be an art as important as painting and drawing.

In general, cultured people in the West are far less sensitive to subtleties of form and will accept any lettering style as long as it is legible. Yet the legibility of letters has absolutely nothing to do with the quality of their forms: it only means that they can be quickly recognized. Two lettering styles may be equally legible, but they can still differ in artistic worth as much as the

*Origins of
modern letterforms
Fig. 3*

The mystery of runes

*Glagolitza and Kyrillitza
Numerals*

*Legibility
Beauty of forms*

creation of a master differs from the work of a bungler. You will never be able to judge the real worth of written forms unless you learn to observe critically and to understand the rhythmic interplay of strokes and negative spaces that goes on in each letter, within each word and throughout the lines on a page.

In the hands of a capable artist, the forms of our alphabet can offer all sorts of creative interpretation: they give shape to fantasies and fairy tales, to the doctrines of philosophers, the laws of science, the inspirations of poets and even provide useful information for consumers. Thus, the lettering artist takes mere communication and raises it to the level of art through imagination, empathy and skill in design.

The invention of printing in Europe in the 15th century brought about many changes and marked the beginning of a new era for the ever-expanding influence of writing.

Writing in our technological age

Writing has long contributed to the growth and progress of industry, but in our own time these very contributions have helped to produce media which compete with writing (telephone, cinema, radio, television, tape recording), and which meet the same needs (communication of information and news, instruction, advertising, entertainment). All these have eclipsed letter writing and newspaper reading, as well as reading for enlightenment and/or for pleasure.

We therefore find ourselves once again in an era of momentous change. Could it be that writing will fade in importance, with other media upholding and passing on our oral traditions from generation to generation?

The attraction of a new approach to lettering

I believe that certain communications media exert a positive influence on people, and it is these institutions that must now band together to preserve and perpetuate the spirit and substance of our oral traditions. In the past, culture taught us to express ourselves—both orally and visually—with clarity, beauty and meaning. Modern technology offers the possibility of even greater achievements, but our present attitudes often cause us to exploit technology for the wrong reasons and even to worship technology itself. We must see to it that responsible and sensitive use of language moves out into the world as a whole, well beyond the narrow confines of the book world, so that it permeates all that we encounter and even what we consume.

The work that we produce as lettering artists and typographers often undergoes machine processing at some stage of its development: letterforms become typefaces after extensive design and technical considerations; the typesetting process composes the text in a musical arrangement of notes and pauses; and the supreme assembly of processes and artistic skills is the book, whose elements all work together to make a balanced whole. In all of this,

our hearts must be vigilant and must weigh what both intellect and hand produce, in order to maintain harmony and purity of expression.

We as individuals and lettering artists can help to preserve our oral traditions by choosing texts that are meaningful and that shed light onto our lives; the resulting written language will have significance and integrity. This approach to work and art could be a new beginning: the reaffirmation of our age-old linguistic traditions and the establishment of positive directions for our future use of language.

Rough design for a medallion

This is my vision of a studio for lettering and book design: it is a place where simple, elemental shapes are joined together in precise harmony and soon awaken as meaningful communication—all in an atmosphere of warmth and wonder. I see a never-ending chain of evolution stretching between two poles, picking up each new cadence of language as it appears, and adding it to the mainstream.

The planning and shaping of our environment has become an important responsibility of all teachers, students and practitioners of the visual arts. And yet surprisingly enough, the general public has no real notion that the written

Written environment

substance of our environment has any bearing on design or, even more important, that its presence all around us constitutes an environment in itself. Architecture excluded, written forms are the most visible feature of our man-made surroundings.

We are deluged with printed material every hour of every day and our culture consumes it in immense quantities. The existence of this written information imposes a moral and ethical responsibility on both client and designer, for it is too much with us to be ignored. Furthermore, our modern industrial society is the consumer of all this information and as such can little afford to be visually illiterate.

The more we come to see and understand the presence of a "written environment" around us, the more we see that the fine arts must meet the challenge and become the serious creators and custodians of this environment. Writing is order; it is the means to a higher consciousness.

Modern people are not well-disposed toward handwritten texts when so many technological alternatives abound. Penmanship is either played down or totally ignored in schools, dismissed as being difficult, boring and uninteresting. However, the qualities of symbolic and meaningful expression present in handwritten material make it that much more important for us to uphold them in today's world. For this reason, lettering and typography must be cared for and developed so that they can fulfill new goals, challenges and functions.

With all this in mind, the lettering artist reaches a decision as he makes his way from handlettering to the realm of books and publishing: he gives himself over to those values which confirm his nature and strengthen his beliefs and knowledge. This commitment stirs and challenges his entire being.

The artist uses the architectural quality and order of letters and layout to express ideas with power and feeling. The texture and form of the printed words grow out of the inner meaning of the text and create a special statement; something personal and essentially human flows out of a purely mechanical process. The degree to which this happens will obviously depend on both the content of the text and the designer's talents.

3 Inscription on the Trajan Column in Rome, 114 A.D.

12

SENATVS PO
IMP CAESARI
TRAIANO AV
MAXIMO TRIE
AD DECLARAN
MONS ET LOCVS TA

If we are to succeed as the custodians of our oral traditions, it is essential that we all choose and create texts that have real meaning for us, so that people reading the words at a later time will sense the emotional solidity and truth in what they read. At the same time, we must also see the letters as abstract shapes contributing to the overall appearance of the text. These two aspects of letters are quite inseparable, just as they are in the mind of a small child who looks wide-eyed at a book for the first time: content and abstract shape are part and parcel of the overall message.

The best way to encourage these aspects of lettering is to work with a palette of historic forms, each one stylistically pure and full of beautiful shapes. To assemble a palette that covers the high points in the development of western lettering, I would choose seven styles:

1. BLOCK LETTERS, whose shapes echo the qualities of the letters scratched into clay by the Babylonians;

Fig. 3

2. ROMAN CAPITALS, modelled on the letters cut into the Trajan Column in Rome; their beauty and grace have never been equalled;

3. UNCIALS, whose forms developed out of the Roman capitals. They have a more calligraphic appearance because they evolved through the use of brush and pen;

4. ROMAN MINUSCULES (lower case letters), the result of the scribes' desire to write more quickly; they were at their most beautiful during the time of Charlemagne [we call this style Carolingian];

5. GOTHIC LETTERS, whose forms abandoned the roundness of Roman letters to take up the angularity and vertical stress of the period, demonstrated so notably in church architecture;

6. FRAKTUR, which represented a partial return to rounder forms;

7. ITALIC, a rapidly written "cursive" hand developed in renaissance Italy and used mostly in the commercial sector.

These seven styles serve as a kind of organizing framework; all seven are still written, printed and read today. From them we can create an infinite variety of forms, but that comes as a later task; at present, you should concentrate on getting to know the seven basic styles.

Be aware of letter shapes. A solid grasp of quality and rhythmic spacing in letterforms is a great help to your overall understanding of the principles of art; this includes both the established conventions and the possibilities for new directions of expression.

Writing thus contributes to your aesthetic development on several levels:
a) as communication, b) as a sculptural medium, c) as environment, and d) as a way of contemplating art through the act and process of lettering.

14

Concentrate primarily on the forms of the letters, and on joining single characters together to make words, sentences and communication. The action and rhythm of lettering will become a guiding force for you; eventually, you will learn to pay as much attention to the negative spaces between letters and lines as you do to the written forms themselves. You will begin to sense certain movements of the pen as "right" and will start to function as a special kind of seismograph, transmitting thoughts and feelings from your head down through your arm and hand to the pen. The author's words are thus beautifully transformed into rhythm, movement and music. True expression comes alive only through this process of feeling and sensing.

Letterforms and letterspacing

The design of harmonious letters comes mostly from feelings and instinct. Fixed standards and rules of design often do more harm than good.

A sound program of lettering instruction will highlight the tension between order and chaos, the importance of the tiniest details, and the universal laws that are present at the root of every creative act, be it the building of a cathedral, the design of a book or the layout of a stamp. A feeling for beautiful form, proportion and rhythm is central to all the fine arts; there is no better way to develop this feeling than to use it actively in design.

Practice on your own as much as you can, taking note of different graphic effects and experimenting widely. Seek out and treasure the sense of rhythm that is present whenever you write; it not only helps with words, but also gives you a new perspective on the artistic world in general. A person who is well-versed in the rhythms of writing has a deeper understanding of works of art and can better identify with the feelings that the artist is trying to express. It is important that the discipline of writing be spread as widely as possible through our culture, since the general public stands to gain so much from it. Writing and lettering can make essential contributions to instruction in every field of design.

Let us therefore write letters with pen, brush, quill and reed—to give them a character and expression only made possible by the shapes of these tools. The surface that bears the letters is equally important: letters carved into stone with a chisel have an entirely different feeling from those written on a sheet of paper with pen and ink. In the same way, the absolute, final forms of a typeface as pieces of metal or computer matrices are always different in spirit and detail from the original handlettered designs.

Lettering tools and their effects

Lettering comes from simple writing. The best way to begin is to write simple block letters (all capitals) without worrying about the particular shape of any of the letters; just write what feels familiar and comfortable. In this way you can preserve some of the special traits of your hand and imagination, without having them swallowed up by stringent rules. These traits will be of great use to you as you develop carefully written styles and fine-tune your techniques for expression; don't lose them now by doing slavish copying!

If you watch young children, as well as those older ones who haven't lost their innate sense for expression, you will see that they paint, draw and form the alphabet all at once. They are trying to reach the fullest level of expression for their ideas, but they have no consciousness of the processes involved. There is something very primal about these modes of expression, something that reaches back to prehistoric man and the earliest glimmer of human consciousness. Before they know all the "rules" children will often write from right to left, from top to bottom or vice versa; this just shows that we may sense more of the possibilities for human expression than what we know for certain. Writing is a clasping of hands across the millennia; the realization of our yearnings for communication, tracing our path from the dawn of our origins to the mysteries of the future.

Such observations should give every teacher and scribe pause to reflect; they should infuse every beginning with special meaning, every time someone picks up a pen for the first time. Whenever students work with a kind of "free association" and pull letterforms out of the depths of their imaginations, the teacher must look with great care and feeling, searching out all glimpses of primal human expression; these sources of creative power must be recognized, preserved and encouraged to blossom.

And what about differing tastes in form and graphic expression? Why do Semitic people write with thick horizontal strokes and Western people with thick verticals? Unfathomable questions, whose answers lie somewhere deep in the spirits of cultures, in their histories, their fundamental structures and perhaps even within the influence of the stars. I raise these quesitons as food for thought, but do not pretend to have the answers. If there are answers, they would fill many volumes.

The teacher's greatest responsibility occurs at this juncture: knowing when to preserve something in a student's work and when to recommend change and improvement. It is a shame that so few people have been trained to teach in this way.

There are two basic aspects of lettering: the forms themselves, and their rhythmic arrangement along a line. The ideal forms can be found on classical Roman monuments, carved into stone with timeless beauty and grace, the seeds of our present Latin alphabet.

It is absolutely necessary that you learn to feel the elastic spaces between letterforms and to either close them up or space them out to obtain a uniform texture and color in each word. A mathematical measurement might show some to be much closer together than others, but the important thing is that they seem the same visually. You can only do this by FEELING. The more you practice, the more you will improve, but you must begin even now if you want to become sensitive and skilled. Later you can break the rules if you wish, but the results are valid only if they feel right to you.

Letterfit and negative spaces

When are the spaces between letters balanced and equal? In general terms, when the patches of white space between letters are the same area. Don't pay attention to the linear distance along the baseline; total area is much more important. Small variations in these spaces are wholly acceptable and actually account for much of the charm and character of handlettering. Some letter combinations are difficult to handle, especially if either of the letters has openings or indentations; a letter can hide a lot of white space in its interior, unnoticeable until it suddenly connects with the white space surrounding the letter. Look at C, G, J, L, T and Z.

Exercises

As you practice, try to develop a feeling for several conditions: the size of the spaces between every pair of letters, the amount of weight and impact they produce, and your ability to make them all equivalent in area. Neighboring letters with straight strokes generally need the greatest amount of space and those with curved strokes the least. One curved and one straight together would obviously fall into an intermediate category. Forms such as C, D, G and O contain so much negative space that the next letter must follow closely if you are to avoid a "hole." It is most important that you learn to feel and judge the negative spaces as you write.

Double forms and ligatures

Another technique for creating even, supple rhythm in your lettering is the use of ligatures and double letters. Ligatures are usually associated with Latin diphthongs such as æ and œ, but the technique can be used to reduce interior space on many combinations of letters. Reducing the amount of space between CH and CK is good practice as long as you preserve the identity of the C. Other combinations benefit from closing up: ft, tt, tz, ss, st and sz. The old form of s (it resembles an Italic *f* at first glance) was abandoned long ago in English but is still used at times in German; it makes for good ligatures in ss, st and sz if the style of the written material permits it. The TT combination of capital letters should blend smoothly into the rhythm of other letters; draw both vertical strokes first to reach the right amount of space, and then join the

two with a single horizontal stroke at the top. Don't put the two verticals too close together or else the result will look like the Greek character "pi."

The very shapes of some letters make for difficulties in spacing. Such letters in combination create too much negative space, even when you have packed *Visual effects of round letters* them as tightly as possible; in this situation, the only way to maintain uniform color and density throughout a word is to spread apart the other letters. This operation makes the word lighter in appearance than other parts of the text, but at least the rhythm within the word is even. The large open forms of O are less objectionable and can even be emphasized at times to provide beautiful changes in the rhythm of your work. Repetitions of the same form then become a decorative element in the fabric of the page.

This brings us to another important point: The optical size of the O and of all the other round letters will seem to be smaller when they are written at a height equal to that of the straight letters, and indeed they are shorter, because they only make contact with the baseline and top line at one point each. The other letters touch more of the lines; look at B, E, F, J, L, P, R, T and Z. To *Letters extending into the margin. See page 21* ensure that round letters look equal in height, extend the curves slightly over and under the lines. Similarly, the pointed forms of the A, V and W should reach somewhat above and below the lines.

Along the side margins of your text, round letters and any other forms lacking a strong vertical stroke at the left should be positioned further out into the margin than letters such as I, B or L.

Make adjustments in spacing whenever you see the need, even if that means a slight modification of the standard form of a letter; for example, the horizontal bar of L can be made very short so that the subsequent letter can come closer and reduce the amount of negative space.

On those letters that are half as wide as they are tall, avoid placing the crossbars at the exact midpoint of the stem: crossbars that come just above the middle will appear to be dead-center, while those placed at the center will look too low. When an adjacent letter also has a crossbar, it looks better to place both crossbars at the same height. Note B, E, F, H, K, P, R and S. Where one letter with a crossbar stands next to a letter with lots of negative space (A, V, J or L, for example), extend the bar into the negative space to reduce the impact of the latter. One should always strive for balanced and intelligent writing that places no impediments on the reader. An even distribution of rhythm on a page flows just like beautiful music.

Ornamental connections between letters The negative space in and around the letter There are times when you can write letters that encroach on each other's territory, making them feel well-connected, or you can take things a bit further with this encroachment and create tension. This will happen when there is little or no space between lines, and it is especially risky if there is a large area

18

of text. A partial solution is to increase the size of the word spaces, but this may not elicit the desired response from the reader.

The study of rhythms in writing is best begun in a way that recalls the ancient technique of scratching, the earliest way of forming letters. On paper surfaces, the ideal tool is a round-nibbed pen such as Redis, Mitchell Script Pen, or the Speedball "B" series. The essential advantage of these pens is that they let you make a complete letter in one continuous stroke; as long as you keep the flat bottom of the nib in good contact with the paper, the strokes will all be of uniform thickness, and the stroke ends will reflect the round shape of the nib. This is the first clear indication that a tool's character can exert influence on the personality of writing. Such shaping is a steady and effortless gift of the pen, welded to the process of producing strokes; it is crucially important that you see and feel it in these beginning stages of lettering.

Round-nibbed pens
Uniform stroke weight
Pen position

I also want to mention how efficient it is to write with rhythm and fluidity. Drawn or built-up letters, whose outlines are established and later filled in, demand much more time than written ones. Even worse is the loss of freshness that you suffer when the continuous stroke of the pen is interrupted. Finally, the spacing is much harder to control because the thinner outlines cannot give you a true sense of what the volume of the letters will be like when they have been filled in.

Disadvantages of
built-up letters

Emblem design

Let's begin! Have ready on the work surface a large sheet of gridded paper (5 squares to the inch, 17" x 22", or 5-mm squares, DIN A2), a 3-mm round-nibbed pen and your ink bottle, which should be open and sitting to the right. Keep the table clear so that you may slide the paper easily from left to right. This lesson explores block letters only; don't be too concerned at this point with the exact forms of the letters—just write them from memory and instinct. A good letter height for this size of pen is 1½ to 2 cm (3–4 squares). Always have a sheet of protective paper under your left hand, to prevent the writing paper from absorbing oils or moisture from your hands. The large sheet of paper must also be clean—even slight traces of oil will cause the ink to spread or bead up.

Begin work writing only words and not individual letters. Choose any text you like (a letter, a poem or a prose passage) and write it out in a steady rhythm, making the best letters you can.

As I mentioned earlier, the round-nibbed pens allow you to make letters in one continuous stroke. While it is possible to do this, a better approach is to learn composite strokes from the beginning. Continuous strokes work only with a round nib; the broad pen that we will use later in letters with thicks and thins will catch in the paper and splutter if you try to make strokes in all directions. It is good technique, therefore, to make each letter from a series of strokes. Note the illustration at left.

Repetitious practice of a single letter or of the alphabet is not productive. Feeling and concentration are both lost when you do this, and the form of the letter can only deteriorate. Letters only reach their real value when they exist within the context of words. Remember: Lettering is communication, form and rhythm all at the same time.

A good practice sheet is incomplete unless you give proper attention to the margins. Thinking about these things helps to build your aesthetic judgment, and you can never have too much of that! A lot of energy and thought put into these relatively simple situations will yield new and imaginative designs later on. There is another reason for proper margins on practice sheets: anything that hand and tool have made together is cause for celebration, and should be displayed with honor and respect.

See page 21

The text should be in the center of the sheet, with side and top margins of equal width and the bottom one about twice that size. These proportions make the text feel properly positioned. If all four margins were the same width, the written area would seem bottom-heavy. You should vary the relationship of bottom-to-side widths until, through experiment, you come up with a size that feels right to you. All these decisions concerning proportion, rhythm and margins should be always on your mind if you want your design sense to become both sound and personal.

20

ABCDEFGHIJKLMNOPQRSTUVWXYZ
AMSTERDAM/BERLIN/CADIZ/DRESDEE/
EDINBURG/FRANKFURT/GÖTEBORG/N
HANNOVER/INNSBRUCK/JERUSALEM/
KORFU/LUXENBURG/MARIENBAD/NÜ
NORDPOL/OSLO/PALERMO/QUEBEC/!
ROM/SALZBURG/TEHERAN/UGANDA/?
VENEDIG/WARSCHAU/XANTEN/YUCAT
TAN/ZWEIBRÜCKEN·1234567890:!?/×!

Equally important are word spaces, whose sizes must appear to be identical even when they differ mathematically. Similarly, the beginning and ending portions of lines should be as close as possible to the limits set by the margins. During the first stages of practice it is entirely permissible for you to break a word in the middle of a syllable, or to add an irrelevant letter or two, in order to keep all your lines equal in width; this way you will always end up with a nicely formed block of lettering.

Always use a large sheet of practice paper so that you can write long lines with uninterrupted rhythm. In this first exercise, leave a 1-cm (2-square) space between lines. Don't correct or cross out any mistakes! If you misspell a word, or if a letterform doesn't look quite right, then repeat the word; if you make cross-outs or re-ink an existing letter, it will disturb your evolving sense of rhythm and order.

At this point I want to give you a tip: if a letter looks pale or washed out due to low ink supply in the pen, quickly refill the pen and dot it into the still-damp letter. Capillary action will pull down extra ink, which then spreads throughout the letter and gives it more density, making the lines of text look like

Block letters (above)
The skeletal forms of Roman letters

Evenness of optical spacing
See above

21

"Gray" letters strings of pearls. On the other hand, you may want to use this "gray" quality to create the effect of alternating light and dark grays; to do so, simply keep a minimum of ink in the pen. Most of the time, however, it is better to make letters of uniform density.

LESSON 2

See page 28 For this lesson, use a different letter height on each sheet, and also change the thickness of the strokes. The appearance of lettering is altered significantly with changes in pen size; consequently you must always try to adapt the rhythm of your writing to new pen sizes so that the page can be easily read, and the spacing is neither too loose nor too tight. After lettering a number of practice sheets, each student begins to feel a marked preference for certain sizes and weights—these feelings are the beginning of personal style and should be carefully noted for future work. Be careful when writing large letters with a small pen! Beginners usually crowd the letters, making their shapes too narrow. Well-proportioned letters are a must if you want your practice sheets to look good.

LESSON 3
See page 23 Lines of large, thin-stroked letters alternating with lines of small, thick-stroked letters. Letter height 3 cm (6 squares), 1½- and ½-mm pens. Write a line of large letters, then switch to the thick pen and write a line of small letters, then back to the thin pen, responding to the necessary changes as you go. Try a sheet with no space between the lines, then another with 5 mm (1 square) of space. Keep practicing until you have mastered the transitions from one weight and size to the next.

Maintaining constant space between letters One important rule for all work, free or structured, is that the space between lines should never be changed once it has been established. Make an instinctual decision about the amount of line space and, even if it proves to be wrong, stick by it if you can. If something must be changed, alter the character of the lettering or the amount of space between letters. The less you disturb the rhythmic flow of lines, the easier it will be for someone to read your lettering. A straightfoward and modest style often intensifies the content of the text. Should you need more space between lines, skip a whole line. These "breathing" spaces are also appropriate at the ends of paragraphs if the style of the text permits. In doing this, you also preserve the rhythm of your lines since all of them still conform to an underlying pattern. This is very important in books, or for any work that will appear on multiple pages. On each page, the lines will all flow with the same pace and rhythm, lending additional strength and order to the whole.

ZEILENWEISES WECHSELN VON GROSSEN DUENNEN MIT KLEINEN DICKEN BUCHSTA

ABEN·IM FORTLAUF GESCHRIEBEN·UM DIE FESTIGKEIT IM RHYTHMUS ZU UEBERPR

UEFEN·DER UNGEUBTE SCHREIBER HAT ZUNAECHST HEMMUNGEN DIE GROSSEN DU

NNEN FORMEN IN VOLLER BREITE AUSZUBILDEN·SIE FALLEN IN DER REGEL ZU SCHI

MAL AUS UND BIETEN DAHER DEM AUGE EINEN FREMDEN DUKTUS AN·DER IM GE

GENSATZ ZUR WOHLGEFORTEN KLEINEN SCHRIFT STEHT·JE WENIGER DIE SEITE IM

23

LESSON 4
See page 25 Now that you have come this far, something more difficult is in order: experiments with balance. Use a sheet of gridded paper in vertical format, writing lines of uneven length with a ¾-mm pen in letters 5 mm high (1 square). Do not insert any space between the lines. Begin and end each line wherever you wish, but don't allow the block of lettering to "lean" toward either side or to appear too ragged. An invisible axis down the center of the block will preserve order, while still allowing the individual lines to be free. It is very important that you do these lines spontaneously, without a preconceived plan. As you letter, look up from time to time to see if there is too much weight on one side; if so, compensate by making the next lines tend more toward the opposite side. Refer to the illustration on page 25. Always pay attention to the area immediately surrounding each letter or word, and never underestimate the influence of the margins, whether they are simple white areas or full of complex decoration. The difference in effect between narrow interlinear spaces and wide ones is also important. Experiments with all of these variations will train your eye and give you a good sense of page "color," of the texture of your work. The goal here is:

Rhythm – Form IMPROVING THE FORM AND PLACEMENT OF LETTERS. Most of our work concentrates on the placement and layout. This is the source of creativity in lettering, experiencing and giving order to the page through form and rhythm. The intensity of this expression will always depend on one's experience, skill and talent.

Practical applications of lettering When you have mastered the forms and rhythm of the block capitals, it is time to use them in a project. This will be stimulating and educational, since it forces you to make decisions and to take risks. I have my students design a children's book; each person chooses a favorite story from childhood as this attachment and interest will greatly influence the outcome of the project. Block letters are well-suited for use in children's books because of their simple and open shapes. You can make illustrations with the same pen that you *Fig. 72* use for writing the text: the heavy line weight will force you to keep the drawing on a larger and simpler scale, thereby creating a strong bond between text and illustration.

You can also use color in the design of your book; anything done in color with the round nib will lend a feeling of decoration and illumination without demanding a great deal of skill. A two-page spread designed in this way can be fun to do and even opens up possibilities for other work in the future. Collage is an excellent technique for this first project: old magazines contain limitless shapes and colors that you can cut out and paste together to make illustrations.

24

›DIE LIEBE ZU EDELSCHRIFT
UND BUCH IST DAS BAND, DAS UNS VEREINT.
WER DER PFLEGESTÄTTE ANGEHÖRT,
IST IN KEINER LISTE VERZEICHNET UND
MUSS ES IN SEINEM INNERN FÜHLEN.
HOHE SCHRIFTQUALITÄT UND GESTALTUNGSKRAFT
SIND VORBEDINGUNG.
NUR WER SICH DURCH SCHRIFTSCHREIBEN
BEGLÜCKT FÜHLT
UND EDELARBEIT LEISTEN WILL,
MIT DEM ZIELE AUF SCHRIFT- UND BUCHGELTUNG,
GEHÖRT ZU UNS.
SO KANN DER LÄRM
UND DAS UNREINE WOLLEN DES ALLTAGS
AN UNSEREN KREIS NICHT ANDRINGEN.
WIR SUCHEN DAS, WAS WIR IN UNSEREM
HERZEN TRAGEN, UND WOLLEN ES
REIN BEWAHREN. RUDOLF V. LARISCH.
MÖGE DIE PFLEGESTÄTTE
DIESE SEHNSUCHT ERFÜLLEN HELFEN.‹
DIE SELBSTVERSTÄNDLICHKEIT, MIT DER
WIR HEUTE DIE SCHRIFT ALS EIN EIGENGESETZLICHES
KÜNSTLERISCHES DARSTELLUNGSMITTEL VON VIEL-
GESTALTIGEN UND UNERSCHÖPFLICHEN
AUSDRUCKSMÖGLICHKEITEN
ANERKENNEN, PFLEGT UNS IM ALLGEMEINEN
GANZ VERGESSEN ZU LASSEN,
DASS DIESE STARKE POSITION,
WELCHE DIE SCHRIFT NUN AUF
FAST ALLEN ERSCHEINUNGSGEBIETEN
UNSERES KULTURELLEN LEBENS EINNIMMT,
ZULETZT NUR DAS RECHT MÜHEVOLLE
ERGEBNIS EINER KAUM MEHR
ALS VIER JAHRZEHNTE DAUERNDEN
ENTWICKLUNG IST. WENN MAN SICH HEUTE
EINMAL RÜCKSCHAUEND WIEDER IN JENE
LETZTEN JAHRZEHNTE BIS ZUR
JAHRHUNDERTWENDE ZURÜCKVERSETZT, ALS ES
GERADEZU NOCH EIN WAGNIS WAR,
DIE WORTE ›SCHRIFT‹ UND ›KUNST‹
BEGRIFFLICH MITEINANDER ZU VERKNÜPFEN,
UND WENN MAN DEM ALLGEMEINEN SCHRIFT-
VERFALL JENER ZEITEN UNSERE HEUTIGE
SCHRIFTKULTUR GEGENÜBERSTELLT,
SO WIRD MAN AUS DIESEM
ZEITLICHEN ABSTAND HERAUS DAS
IN DIESEN LETZTEN JAHRZEHNTEN
AUF DEM GEBIETE DES SCHRIFTWESENS
GESCHAFFENE UND ERREICHTE ÜBERHAUPT
ERST RICHTIG ANZUERKENNEN UND
ZU WÜRDIGEN BEREIT SEIN.
DIESES UNBESTREITBARE VERDIENST
FÄLLT DEM GROSSEN ÖSTERREICHISCHEN
SCHRIFTKÜNSTLER RUDOLF VON LARISCH ZU,
DER ALS ERSTER WIEDER AUF DEUTSCHEM
SPRACHBODEN ÖFFENTLICH UND
MIT ALLEM NACHDRUCK FÜR DIE SCHRIFT
ALS EIN KÜNSTLERISCHES AUSDRUCKS-
MITTEL EINTRAT, DER SEINE
SCHRIFTERZIEHERISCHEN GEDANKEN
ZU EINEM KLAR DURCHDACHTEN LEHRSYSTEM
AUSZUBAUEN VERSTAND UND DEM DAHER
AUCH OHNE HIER ETWA DIE
AUSSERORDENTLICHEN VERDIENSTE
EINES EDWARD JOHNSTON, DES ANDEREN
GROSSEN EUROPÄISCHEN SCHRIFTREFORMATORS,
SCHMÄLERN ZU WOLLEN - DOCH WOHL
DEUTSCHLAND SEINE EIGENTLICHEN UND
NACHHALTIGSTEN SCHRIFTKÜNSTLERISCHEN
IMPULSE VERDANKT.

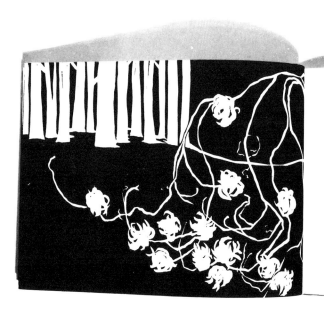

WEITER UNTEN WURDE DAS TAL BREITER UND FREUNDLICHER·
TRAUBEN WURDEN GEERNTET UND NÜSSE VON DEN BÄUMEN GESCHLAGEN·
DER ORT·IN DEN WIR KAMEN·WAR EIN IRRGARTEN
VON WEISSGEKALKTEN TREPPEN UND ÜBERWÖLBTEN GÄNGEN·
MIT HAUSTÜREN UND HAUSNUMMERN·
MIT FENSTERN VOLL ROTER GERANIEN UND SCHWARZEN KATZEN·
DIE AN FISCHKÖPFEN NAGTEN·EINMAL TAT SICH DORT EINE TÜR AUF·
UNTER GLASSTURZEN STANDEN WACHSERNE HEILIGE
STARR UND FURCHTERREGEND·
UND AUS ZERWÜHLTEN BETTEN KROCHEN BLASSE SCHÖNE KINDER·
IMMER MEHR·WIE LARVEN AUS EINEM SUMPF·
DRAUSSEN HÄMMERTE DIE GLOCKE·WIR GINGEN WEITER·
UND ALS WIR AN DEN STRAND KAMEN
WAR ES DUNKEL·UND DIE ERSTEN FISCHER
ZÜNDETEN IHRE LAMPEN AN UND RUDERTEN HINAUS AUFS MEER·

IN MEINER HEIMAT GINGEN WIR UM DEN ÖLBERG·
DEN GROSSEN AUSSICHTSWEG AM RANDE DES URSTROMS·ABER KEINE
SPAZIERPROMENADE·TROCKEN UND BEQUEM·
DER PFAD FÜHRTE IM BUCHENWALD HINAUF ZU DEN REBBERGEN·
DANN ZWISCHEN KAHLEN WEINSTÖCKEN WEITER·
SCHWERER GELBER LEHM HING AN UNSEREN SCHUHEN·
DEN WIR MIT EINEM STÖCKCHEN ABKRATZTEN VON ZEIT ZU ZEIT·
UM DEN BERG HERUM LIEF EIN FAHRWEG MIT TIEFEN RADSPUREN·BLAUES·
HIMMELSPIEGELNDES WASSER DARIN·WEIHNACHTSZEIT WAR·
ABER WAS BEDEUTET DAS HIER·AUF KEINEN FALL SCHNEE·
VEILCHENZEIT·FÖHNZEIT UND GROSSE SONNENTAGE DAZWISCHEN·
UND AN EINEM SOLCHEN SONNENTAG GINGEN WIR UM DIE KUPPE DER BERGE·
VORBEI AN HÖHLEN DER VORZEIT UND RINGEN·
AN DENEN EINMAL BOOTE BEFESTIGT WAREN·DAMALS·
ALS NOCH DAS MEER AN DIE KALKFELSEN SCHLUG·
AM WALDRANDE SASSEN WIR·BEI HECKEN ROSEN RANKEN UND GRAUER
WOLLE DER WALDREBE UND HIELTEN EINANDER DIE DORNENZWEIGE·

4 Two 2-page spreads from a story written, illustrated and lettered by a student for a thesis project. 1978. Block letters. Text areas are ragged-left or -right, and of proper weight, to match linoleum prints on facing pages.

Whenever you learn a new lettering style, always follow up your practice sheets with a project like the one I've just described. Be sure that the lettering style can express all the feelings of the text, and make the details consistent with one another so that they work as a whole. You will learn a great deal when you produce this sort of project.

26

Good lettering must satisfy all these conditions: simplicity, clarity, proportion, beautiful form, consistent rhythm, good composition, and the personal spirit that distinguishes your letters from those written by any other hand.

The distinct character of hand and tool working together is what dignifies lettering and lends it style, often helping to both simplify and strengthen a design.

FORM Since beautiful form is a natural outgrowth of hand and tool, we can use the old, clear and beautiful pen-written forms that have remained essentially unchanged for centuries. Personal expression is an integral part of high quality lettering, but it grows slowly from the classic models, almost undetected, becoming stronger through time and practice.

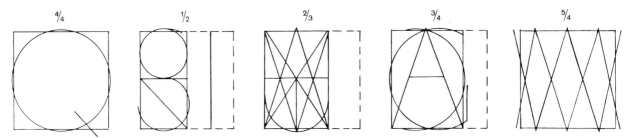

The "classic" proportions

The letter "O" provides the single most basic form; the proportions of letters derive from it (either a single O or two in a vertical stack) and many letters have at least a partial echo of its curved shape. The narrow letters, B, E, F, P, R, S, Y, are half as wide as the O and Q, like two small "O" shapes stacked above each other. J and L are also this width, because their open forms contain a good deal of negative space and they would become too light in "color" if they were made wider. The letters of medium width are separated into two distinct groups for aesthetic reasons—some look better a bit wider, others narrower. A, H, K, N, T, U, V, X, Z are 2/3 the width of O, and C, D, G are 3/4 the width. The remaining letters are: I, which is only one stroke wide; and M and W, whose shapes extend horizontally and are slightly wider than they are high (5/4 the width of O).

These proportions are useful for most styles of roman capitals and lower-case letters, and for italic, all of which we will examine later. However, even your beginning practice with block letters should fully embrace this spirit of shape and proportion.

Continue to practice in one size, with one degree of letterspacing, until you can maintain a constant rhythm throughout your lettering, even with interruptions of several days between work sessions. Once you have mastered that size, you can go on to something new; but then you must pursue that, too, until you have a real feeling for its letterforms and rhythms. The students at my school typically need a full week of practice, sometimes even longer, to reach this level of familiarity. Individual aptitude and previous experience have a lot to do with learning speed.

Keep these principles in mind whenever you start on something new. The more you work at lettering the easier it will be for you to reach your goals, and the less time it will take. Patience and inner calm are a big help in this discipline.

28

ABCDEF

GHIJKL

MNQPR

STUVW

XYZ'?!O

23456789

Broad pens have greatly influenced the development of letterforms over the last 2000 years. Their chisel-shaped nibs make the characteristic thick and thin strokes so closely identified with calligraphy, and they can be used in both "flat" and "angled" positions to obtain different effects.

The pen may be held so that its straight edge is parallel to the baseline ("flat") or so that it forms an angle of anywhere from 0° to 45° or more with the baseline ("angled"). Lettering styles done in flat pen usually have ample space between letters and are austere, round, solemn and clear. While both Roman and Uncial share these characteristics, they are particularly strong in the Uncial. The angled pen produces letterforms that relate closely to personal handwriting; they are more fluid and tightly packed than flat pen forms. Words in this style look narrower and darker in "color" and are less formal at the same time. This is most obvious in Roman letters written with an angled pen.

Roman caps with angled pen: 3 mm broad pen, letter height 1.5 cm, interlinear space 1 cm. In this exercise you will continue to write the same shapes and proportions of capital letters, but with a broad pen held at a consistent angle. Place the straight edge of your nib on the paper so that it forms a 30° angle with the baseline; this angle will produce vertical strokes that are a bit thicker than the horizonal strokes. To make the thinner strokes of M and N, you'll have to hold the pen at an angle closer to the vertical—perhaps 60°.

It is now time to learn some lower-case letters that match the capitals. The pen angle is the same and this time there are no exceptions (as M and N were above). By the mere addition of thicks and thins, this style has a very different feeling from that of the round-nibbed block letters. These forms are lighter, more elegant and closer to typographic shapes. The changes in stroke weight make the rhythm more complex, as do the ascenders and descenders of the lower case (the parts of the letters that protrude above and below the mainstream or "x-height" of the letters). You should be able to adjust fairly quickly to these changes in rhythm, however, and once you have mastered them, you

will have added to your repertoire a style with real personality and character. It is especially useful for long texts and for special citations and documents.

The beautiful simplicity and clarity of this style require that you pay close attention to the forms themselves and not to flourishes and decoration. Very understated serifs are the best, since they accentuate the ends of strokes without being a distraction: make them by pulling the corner of your nib up and out from the end of the stroke in a simple, rhythmic movement.

Aa Bb Cc

Dd Ee Ff

Gg Hh Jj

Ii Kk Mm

Ll Nn Qq

Stroke directions

RBCEM gott

Pp Rr Ss
Tt Uu Xx
VvWwYy
Zz·ı! 123
456789
OKUVSZ O

Short ascenders and descenders are an important aspect of this style. They create the impression of a string of pearls and increase legibility, since the reader's eye can move smoothly along the x-height of the letters and isn't interrupted by long ascenders and descenders. Capital letters, numerals and the larger punctuation marks should be the same height as the ascenders. Write the numerals so that they have the same spirit and "color" as the other letters. Punctuation marks, quotation marks, asterisks, crosses and other decorations all make use of the same pen angle, and for contrast can be written in a second color.

Ascenders and descenders

Punctuation marks

Bookplate

Verborgene Liebe

Komm/Geliebte/laß uns wallen
aus der lauten Welt!
Trunken wo schon Harfen schallen·
Träume von den Sternen fallen·
Komm/Geliebte/laß uns wallen
in der Wonne Zeit!

Sieh/wie Glanz aus ewigen Sphären
quillt's von Brust zu Brust!
Was die Götter uns gewähren/
kann die Welt uns niemals wehren/
frei ist alle Lust·

Die vorm Tage scheu verglühte
Liebe nun erwacht·
Vor der Welt dich hüte/hüte!
Unsrer Liebe Dornenblüte·
lebt vom Tau der Nacht·

Richard Billinger

9 Richard Billinger.
("Secret Love"). 1966. From
a series of poems. Roman
minuscules written with
angled pen. Simple-but-
related proportions. White
letters on colored back-
ground. Original size
70 x 100 cm.

Auferstehung†

Bald fliege ich von dannen,
mein Kerker birst entzwei!
Und die mich wollen bannen,
erwürgt der Engel Schrei.

Auffahre ich und lache
und gürte mich mit Licht,
daß ich mich fertigmache
fürs himmlische Gericht.

Meine Seele hocket heiter
als Taube auf dem Dach
und flieget fort und weiter,
und Trauer glänzt ihr nach.

Richard Billinger

10 Richard Billinger.
("Resurrection"). 1966.
From the same series.
Roman minuscules written
with angled pen. Letters in
title are condensed. Stanza
initials in italic. White letters
on colored background.
Original size 70 x 100 cm.

Uncial is the next style. Be prepared for some difficulties at the outset because you must write with a flat pen, and this is not a natural or comfortable position for the hand. The flat pen Roman caps are even more difficult, however, so Uncials are a good place to begin.

Beauty of form

The Uncial hand dates from the first centuries after Christ. It has a simplified version of the monumental Roman capitals that had been cut into stone or written with reed and brush. Uncials were still basically capitals, but several of the letters had already begun to shift toward the minuscule (lower-case) forms which were to dominate lettering in the centuries to come. There are already ascending and descending strokes present in d, f, g, h, k, l and p; and the forms of a, e, m, n, v and w are close to their modern counterparts. A beautiful vitality springs from the open, round forms of this hand, but this verve also hampers its legibility for those who aren't used to reading it. We can only hope that it will be used more in advertising and publishing, and thus gradually come to win acceptance.

Bookplate

ABCDE
FGHIJK
LMTQP
RNSUV
WXYZ·'!
?12345

abcdeh
gfijklm
nopqrs
tuvwyx
zAntiqua
67890

GEBET

Herr Gott, der du thronst in
Sternenklarheit
 ÜBER DEM LAND,
Deiner Lenden Gürtel
Wahrheit, Wahrheit
 DEIN GEWAND·
Herr! Durchleuchte mich mit
deinem Lichte
 GÖTTLICH KLAR,
Was da Lüge ist in mir,
vernichte,
 MACH MICH WAHR·

Enrica v. Handel-Mazzetti

16 Enrica von Handel-
Mazzetti. Prayer. 1967.
From an anthology. Alter-
nating minuscules and
capitals, written with flat
pen. White letters on colored
background. Original size
14.5 x 23 cm.

43

KEPLER JOHANNES

GROSS IST GOTT'
UNSER HERR' UND GROSS
IST SEINE HERRLICHKEIT'
UND SEINE WEISHEIT HAT
KEINE ZAHL' LOBPREIST IHN'
IHR HIMMEL' LOBPREIST
IHN' SONNE' MOND UND
PLANETEN' WAS EUCH
SINNE ZU SCHAUEN IHN'
WAS EUCH ZUNGEN ZU
RÜHMEN IHN SIND·
LOBPREIST IHN' IHR
HARMONIEN DES HIMMELS'
LOBPREIST IHN' IHR
GEISTIGEN HARMONIEN·

Wip vil schœne nu var du sam mir·
 lieb unde leide Daz teile ich sant dir·
Die wile unz ich daz leben hân sô bist du mir vil liep·
wann minnestu einen bœsen/ Des engan ich dir niet·

DER
VON KÜRENBERG

18 Der von Kürenberg.
Love poem. 1967. From an
anthology. Lower-case
Gothic letters, written with
angled pen. Decorative
letter and author's name in
Roman caps, written with
flat pen. White letters on
colored background.
Original size 14.5 x 23 cm.

The Gothic style ushers in an entirely new world of rhythm and letterforms. Many letters that were round up to this time are now broken into straight and angled lines and conform to a regimented pattern of black-white-black. This rhythm remains constant throughout the text, interrupted only by the occasional capital letter. These interruptions can actually create a very pleasant effect, especially in German where every noun is capitalized. These letters have much in common with gothic architectural style: high, narrow forms reaching toward the heavens.

*Problem letters
See above*

For capitals: 3-mm broad pen, letter height 1.5 cm, interlinear space 5 mm. For lower-case: 2-mm broad pen, letter x-height 1 cm, interlinear space 1 cm. Begin with the lower-case so that you experience the new rhythm in its entirety and thus master it quickly. Hold the pen at an angle of 40° from the baseline, thus making the horizontal strokes almost equal in weight to the verticals; this also produces square ends on the strokes and allows each letter to connect precisely to the next. The letters e, c and r have an open, negative space to the right and consequently make white spots in the flow of letterforms; to get around this, write the following letter much closer than normal by leaving off the angled stroke at upper left and thus reducing the amount of white space. Refer to the "ei" combination in the illustration at left for an example of this technique. Please note that there are rectangular strokes on some letters and square strokes on other—these are not interchangeable and the differences between them are very important! Compare the bottoms of c and e with i, for example.

When you have settled into a steady, fluid rhythm you can try adding some capitals. There are no "correct" forms for these letters in the Gothic style; in fact, the medieval scribes of each region created their own individual versions of capitals. The manuscripts that have survived demonstrate clearly that there were no universal or standard forms. To me this is more pleasant than discouraging, and I urge you to make up your own designs, using whichever details please you. The best method is probably to group Gothic and Fraktur letters according to similar strokes and shapes, and then to develop a style that upholds these similarities. As an example, you could make four groups (B, K, M, N, R, U, V, W, X, Y and C, E, G, O, Q, S, T and F, I, J and H, L), work out some details and decorations, and then adapt the remaining letters to blend in with the others.

Fig. 19 My capital letters are only a suggestion; many of them are merely enlarged lower-case forms. They retain a certain clarity and simplicity, yet because they have more white space in their centers, they are still distinct from the

46

abcdefghij

klmnopqrs

ſtuvwxyzʒk

1234567890

Abend Baum Cä

sar Dora Edgar

ABCDEFG
HIJKLMN
OPQRSTU
VWXYZ†

ABCDEFG
HIJKLMN
OPQRSTU
VWXYZ�֍

Adam · Berta · Christl ·

David · Edith · Hugo ·

Fritz · Gabriel · Marie ·

Ida · Josef · Karl · Liese ·

Nora · Otto · Quester ·

Paul · Rita · Susi · Teo ·

Ulrich · Viktor · Willi ·

Xaver · Ypsilz · Zephir ·

21 Gothic lower-case
mixed with Fraktur
capitals, written
with angled pen

Figs. 20a/21 lower-case letters. In my examples of capital letters, I have tried to indicate some of the many possibilities of letterforms and decoration that are open to you; just remember that the form you choose should have some relation to the meaning of the text.

Fig. 19 One variation that I often use is the mixture of Gothic lower-case with Uncial or Roman caps. These are written with an angled pen to create a uniform mood of stroke shapes despite a difference in the basic forms of the letters. This technique increases the legibility of the text and means that you can probably make more frequent use of Gothic as a result.
It is a shame that the world is unaccustomed to reading Gothic and therefore labels it illegible, for such a historic and important lettering style deserves better than to be abandoned and forgotten.

Figs. 18/22 The variations in form and expression permitted by the Gothic style are almost unlimited! As a beginning experiment, write lines of extremely varied letter heights while maintaining a constant pen size, and observe the differences.

Bookplate

Ihr Freunde/die mir noch zum Trost und Freude leben/
Nehmt diese meine Schrifft zu euren Diensten an.
Ich weiß euch anders nichts/als dieses Buch/zu geben/
Darinn ich mich/und ich euch/wieder sehen kan.
Ich dencke offtermals an jene süße Stunden/
Da wir in voller Lust beysammen konten seyn/
Die Laute ist verstimmt/die Zeit ist nun verschwunden/
Die finstre folget stets auf klaren Sonnenschein.
Der wohnet gegen West/der andre gegen Morgen/
Der auf erhabnem Berg/und jener in dem Thal/
Bald sind wir frohes Muths/bald wieder voller Sorgen/
Die Menschen sind doch nur des Glückes Wunder-Ball.
Zu denen gehe hin/wo ich nicht kan gehen/
Mein Buch und sprich/daß ich noch voller Flammen leb/
Auch/daß in solcher Glut mein Leben wird bestehen/
Biß ich der Eitelkeit mein letztes Valet geb.

JOHANN BEER

22 *Johann Beer. Poem.
1967. From an anthology.
Oblique form of Gothic
lower-case with Uncial
capitals. Angled pen. White
letters on colored back-
ground. Original size
14.5 x 23 cm.*

51

3-mm broad pen, letter height 1.5 cm, interlinear space 1 cm. Practice the lower-case first, then the caps, and finally mix them together. Use the practice techniques and exercises from the earlier lessons.

Fig. 25

Fraktur feels quite similar to Gothic in its general massing and spacing, but now there are some rounded strokes to go with the angular shapes of Gothic. Even the straight strokes are rounded at the ends, rather than having two angled sections at the ends; the letters seem softer and a bit more open. This is a handsome and worthy member of the Gothic family.

At times if the text seems to call for it, you can extend the tops of strokes by flicking the corner of your pen. This decorative technique should be used only on a single sheet or broadside, however, and not in a longer text, as it impairs legibility.

The astounding wealth of forms possible in Fraktur comes largely from the decay of pure elements in both Gothic and classical Roman hands. The mixture of these various elements and shapes is as risky as it is attractive, however, and only experienced scribes are likely to come up with new combinations that remain balanced and legible.

*Rough design for a
bookplate*

52

abcdefghi
jklmnopq
rstuvwxy
zðkſſſßß!?

*Use numerals from the
angled-pen Roman style,
but keep them narrow to
match the shapes of Fraktur*

Frakturſchrift·
Ziffern der ſchrägen
Antiqua

A B C D E F
G H I J K L
M N O P Q
R S T U V
W X Y Z F
A B K M S

Herbstbeginn

Der Hirte singt zum Abendstern·
Im Apfel bräunet sich der Kern·
Wipfelmüd die Bäume schweigen·
Nebel in die Wiesen steigen·
Beere sich an Beere hängt·
Zur Aster sich die Hummel drängt·
Der Kern aus reifer Pflaume quoll·
Ein Birnlein in der Faust mir schwoll·
Ich sauge mich ins Fruchtfleisch ein/
die Wange heiß vom ersten Wein·

Richard Billinger

*25 Richard Billinger.
Poem ("Autumn's
Beginning"). 1966. From
a series of poems. Fraktur
written with angled pen.
Condensed letters in title.
Stroke terminations are
slightly emphasized. White
letters on colored back-
ground. Original size
70 x 100 cm.*

55

Sommerruf

Komm zum Schatten meines Waldes,
komm zur Quelle der verborgenen!
Süße Düfte schenkt mein Oden.
Aus den Gärten raubt ich Rosen,
Nelken und Liebfrauenschuh.
Efeu nackter grünt am Steine.
Hummeln, Bienen, seltne Falter
suchen Honig, Harz entquoll.
Lieder kennt ein Traumervogel.
Komm eh' uns die Sterne zürnen
und der Mond die Lüfte meistert!

Richard Billinger

26 Richard Billinger.
Poem ("The Call of Sum-
mer"). 1966. From a series
of poems. Oblique Fraktur
written with angled pen.
Capitals are accented with
an extra line. White letters
on colored background.
Original size 70 x 100 cm.

56

27 Anton Bruckner.
Excerpt from a letter. 1967.
From an anthology. Text in
Italic, author's name in
Fraktur, both written with
angled pen. White letters on
black background. Original
size 14.5 x 23 cm.

Bruckner Anton

*Eigentlich hab ich, was meine Freunde jetzt ›groß‹
nennen, nur fertig gebracht, weil ich von Jugend an
Ehrfurcht gehalt habe vor allem Echten und Heiligen.
Jedesmal, wenn ich ehrfürchtig aufgeschaut habe zum
Vater oder zur Mutter oder zu einem meiner Meister
oder gar zu Gott, da ist mein Herz weit und groß
geworden. Aus solchem Zustand hab ich meine schönsten
Sachen geschaffen.*

Italic occupies yet another world of rhythm and form. A "swift" variation of the freely-written minuscule style, it was used for letter writing and as a copy hand in chanceries; the need for speed in these applications caused the minuscule shapes to gradually lose their upright character, and the result was slanted Italic. This style makes important contributions to the design field and has become increasingly popular in the public eye.

Degree of slant

The degree of slant in Italic lettering is an individual matter and there is no prescribed number of degrees; rather, you must simply find the angle that is the natural outgrowth of your imagination and the physical properties of your hand.

2-mm broad pen, x-height 1.5 cm, interlinear space 1 cm. Start out with lower case, then write caps, and finally combine the two. The basic shape in Italic is a slanted oval. When all letters use this as an underlying structure, the result is an even and steady rhythm.

Italic is ideal for light prose, where it can narrate simply and is not expected to express any special emotion in the text. It works well with poetry most of the time, and actually it can be used as a complement to Roman or Gothic forms in almost any situation. Once again, however, you run the risk of producing an unfortunate or unsuitable combination if you don't think carefully about how things go together. The basic forms of Italic, devoid of any flourishes and swashes, often work best. Then again, Italic can be unleashed into a display of beautiful fireworks, demanding all the skill that an experienced scribe can summon. The rewards from this can be great indeed.

Italic looks best when it is written with a narrow pen. It reads well with less contrast between thicks and thins and it is also more elegant. In addition, thin strokes allow the underlying rhythmic order and oval form of the letters to shine through.

Figs. 22/26

Any of the other hands we've studied can also be written in an oblique or "Italic" version, including the Gothic and Fraktur. This is another technique on your palette of expressive elements; which helps you to breathe the right form and spirit into every piece you write.

Using color to obtain contrast

The hands which you have written up to this point form a sound and basic group. Merely by changing pen size or angle or letter height, the modern lettering artist working in European languages can produce an infinite wealth of expression. There are straight and italic forms, thin and thick, the use of color and illumination. The results must always feel right, however, and must transmit the essence of the text to the reader. Good lettering always remains

ABCDEFG
HIJKLMN
OPQRSTU
VWXYZ Zephir
abcdefgh
ijklmnopqr
sftuvwxyz

28 Italic lower-case and capitals, written with angled pen

59

subordinate to the words it expresses and never permits specific details to disturb or dominate the work as a whole.

Further study will make you aware that, at a certain point, truly artistic lettering leaves off and individual, normal handwriting begins. A sharp distinction between these two areas is difficult: lettering described as monumental or artistic is often totally devoid of rhythm and order (reminiscent of the appearance of most cities), while ordinary handwriting can sometimes embrace all the aspects of good design and be very artistic as a result. Lettering practice will always exert a good influence on your handwriting, and rarely does anyone continue to write awkwardly if he has spent much time working with letterforms. Every cultured person ought to understand how much harmony and expressive power well-formed letters can give to a written page.

Careful lettering influences one's personal handwriting

Bookplate

Der Hauptplatz von Linz gehört, auch wenn ihn
keine paradierende Nationalgarde schmückt, zum
Schönsten, was ich kenne. Während sonst Plätze, nicht
bloß die Ringe, slawischer, sondern auch die lateinischer
Städte, was Kreisendes haben, selber geschlossen und
auch wieder schließend, den ganzen Ort zugleich ein-
schließend und abschließend, beschließend, öffnet sich
dieser Linzer Platz, er schließt sich auf und scheint, sachte
zum enteilenden Strom hinab sich senkend, nach den
Bergen über dem anderen Ufer hin sich dehnend, die
Welt umarmen zu wollen, dieser Platz faßt seine Stadt
nicht bloß zusammen, er führt sie fort, über sie hinaus,
es ist ein bewegender Platz, ins Weite will er, an den
großen Strom hinab, der dem Sonnenaufgang ent-
gegenstürzt, zu den Bergen hinauf, wo schon die Rede
der Menschen nördlich härter wird, weit, weit in die
blauen Fernen hinaus – ich weiß auf Erden keinen
anderen so weittragenden Platz von dieser ausweiten-
den Kraft! HERMANN BAHR

29 Hermann Bahr. Essay.
1967. From an anthology.
Simple, fluid Italic written
with angled pen. White let-
ters on black background.
Original size 14.5 x 23 cm.

61

LETTERING AS
AN APPLIED ART
Commissions
Book design
Advertising

Seek harmony in
composition

The fundamental rule: keep details subordinate to the spirit of the piece as a whole. When the lettering is unaccompanied by decoration, each letter works toward the desired effect. When text is combined with illustration, the letter forms must strive for perfection without overpowering the work as a whole; they must not be too big or too strong lest they become obtrusive. Yet the lettering must always be an active element of the overall composition. Text blocks that have been scattered without reason are ugly and detract from the basic layout of the whole. One way to maintain uniform feeling and appearance is to use the same tools and/or colors throughout a piece, and to make the proportion and shape of text and illustrations either similar or in thoughtful and appropriate contrast. Individual letters and whole text areas can even echo the line quality and form of an illustration, bringing about a special kind of harmony.

An artist's individual taste and his feeling for the "architectural" nature of lettering will often strengthen his use of the above principles and techniques.

Constant attention to content is every bit as important as understanding and using details of design and form, and must in fact be considered a prerequisite of any sensitive design. You need to decide when to let the text speak for itself and when to add decoration. Successful work often contains straightforward text with only a few highly effective splashes of ornament. Constant observation of everyday things is the only way to build a sense of lettering's possibilities and limits. Look at everything, from friezes and mosaics to inscriptions, posters and newspaper mastheads; from exhibitions to billboards and even "No Smoking" signs! Search out differences and similarities in design and expression, such as the varied effects you achieve with brush lettering on one hand or metal printing types on the other.

Tools and materials Experiment as fully as possible with a variety of materials—wood, linoleum, stone, plaster of Paris, metal—and get to know their characteristics through personal contact. Will a certain material be suitable for a given text and graphic effect?

For advertisements and information aimed at the public, good contrast with
the surrounding environment is as important as the design of the piece itself.
If posters are going to be put up on brightly colored walls, turn this to your ad-
vantage and produce them in subdued colors or simple black and white. The
same principles apply to printed ads. When something must go on a densely-
packed page, keep its design light. Broad, white margins are very important,
even if they force some of the lettering to be a size smaller. If the page is grey *Fig. 81*
and monotonous overall, just one word or line in strong contrast will be an
ideal solution. "Reverse" ads (white letters on a solid black background) pro-
vide great contrast, but you should avoid using overly-thin letters since offset
presses often have problems with such fine detail; printer's ink has a tendency
to slur across the thin white lines, closing them up and destroying the legibil-
ity of your work. Good lettering, if it is artistically sound, can enliven even the
plainest thing. It can make shop entrances and displayed merchandise more *Figs. 80/81*
appealing, and in the realm of corporate design, a well-conceived system of
trademarks and graphics will boost a company's image and strengthen the
designer's reputation as well.

I would also like to make some comments about the large domain of TYPE- *The design of printing types*
FACE DESIGN, whose disciplines are most often left to people with extensive and
specialized experience. After surveying the existing array of typefaces to see
what new designs might be needed or appropriate, the designer begins the
long process of developing a typeface. This requires a highly-developed sense
of form and also the patience to evaluate the "fit" of letters in all combina-
tions, over and over again, until there is an even flow of rhythm throughout.
There are so many hundreds of typefaces already in existence, and the differ-
ences between them are sometimes so small (even to an expert), that it makes
one wonder what warrants the existence of some new designs.
Designs for hot-metal type are no longer of use, since few people print
by letterpress; photocomposition and digital composition are the two *Phototypesetting*
avenues open to a modern-day designer. These latter processes, however,
offer many options to the skilled and imaginative scribe. Of particular interest
to the individual artist or small design studio is the headline setter, for which
one can prepare personal type and lettering designs on film. Equipped with
this machine, a typeface designer can develop one particular style for a
specific book and then set the book, producing a facsimile edition of his
hand-drawn forms at minimal cost.
The addition of silkscreen printing equipment—not an unreasonable
expense—completes the studio, making it a fully independent print shop.
The scribe is once again a universal artist, putting his mark on everything
from type designs to beautifully printed small editions.

Activities of this kind deserve the highest order of praise, for they uphold the tradition of fine printing. Wildfire commercial development and the lure of huge editions for mass audiences have caused the printing trade to lose interest in the production of small fine editions. Even the work done by specialized houses has dropped so much in quality that the designer may be forced to do the work himself, if he expects to get something better than "just average." This, of course, is only a possibility if the designer has some experience in the relevant area.

BOOK DESIGN

The hand-written book

The crowning achievement of all calligraphic work is THE HAND-WRITTEN BOOK.

Lettering may often be well-suited to the production of a book, but remember that it can also be used in diplomas, proclamations and posters, taking on whatever form precedent or taste may suggest.

Here, however, we will concentrate on the book. The most important quality is that of consistent appearance: at any point in the book, facing pages must feel as if they belong opposite each other.

As the designer, you must consider such factors as the size and format of the book, the format of a typical page, the size of all four margins and how they will relate to the text and to the page as a whole, and how illustrated pages will differ from text pages. Furthermore there are decisions concerning page "color": the length of lines in relation to letter height, the amount of space between the lines, the number of lines on a page, and the size, color and number of ornamental initials and other decorations.

Paper formats
Book formats

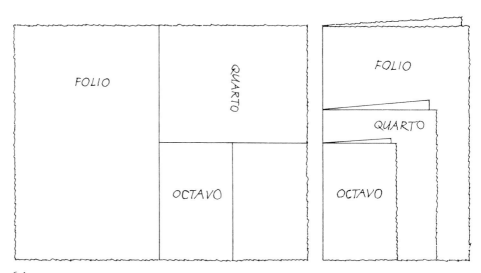

FOLIO

QUARTO

OCTAVO

FOLIO

QUARTO

OCTAVO

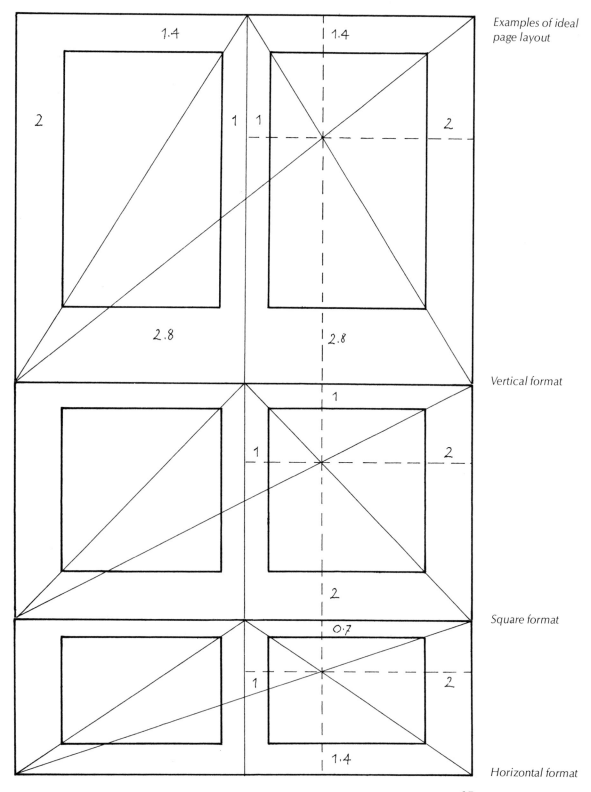

Examples of ideal page layout

Vertical format

Square format

Horizontal format

65

Page formats	The size of your paper is a prime factor in your decisions about the size of text area, margins, etc. Many traditional models have grown up around particular
Hand-made paper	paper formats (see page 65). If you choose HAND-MADE PAPER and try to pre-serve the deckled edge (worth doing if possible!) your page size is essentially predetermined. A folio will leave the deckled edges on all sides; a quarto will force you to cut a smooth edge at the top, but the sides and bottom will still be deckled. If you need to use another format and must trim away some paper, then cut all the edges to keep the appearance uniform. I would recommend tearing only as a last resort, because the resultant edge is artificial and unsubtle, but if you need to do it this is the best method: pull the excess paper along the edge of a wooden ruler, at a steep angle, and the quicker you pull the paper, the sharper and smoother the edge will be.
Text areas and sizes	The size or height of the lettering will determine what a comfortable line width ("measure") will be. Lines of small letters must not be too long or the eye will get lost on its way back to the start of the next line; lines of large let-ters must not be too small lest there be frequent hyphenations and an overall loss of rhythm. Whenever possible look for natural breaks in poetry or metered text, such as a comma or period, since these breaks always seem "right." There are rules and conventions about these things in typography, and it is well worth it for a scribe to explore the techniques of such an impor-tant and closely-related field. Much of the printing trade itself needs to pay closer attention to these rules
	Once the line length is fixed, you must choose the amount of space ("lead-ing") between the lines. Lettering styles that are light in "color" generally require generous leading; styles with darker "color" (Gothic, for example) must have much less leading, or even none at all in some special cases.
Illustrations and decoration	ILLUSTRATIONS or decorations added to the text are best executed with the same tool used to do the lettering. This establishes a uniform appearance on the structural level and also produces a wonderful emotional harmony if the illustrations echo the spirit and meaning of the text. The earliest printed books often bear examples of this harmony: woodcuts and ornaments that perfectly match the Gothic lettering of the period.
	You may add illustration or decoration to any lettering style as long as you remain sensitive to the character of the lettering and understand how an illus-tration might complement it. If you decide to use human figures, remember that they may dwarf adjacent lettering: the letters are only a few millimeters high, but the people will seem, on a subconscious level, to be almost 2000
Fig. 35	millimeters high. Medieval artists conquered this optical illusion by placing humans in a window or frame that separated them from the plane of the

66

lettered page, and made them seem to be farther away. Thus any direct conflict between figures and letters was avoided.

A second method for adding human figures is to set up the text so that it acts as a series of barriers, almost like flats on a stage, and positioning groups of figures in between.

Figs. 37/38/39

In the hands of a master, lettering and heraldic art blend together and complement each other beautifully. The strong geometry and colors of the heraldic elements have much in common with the basic shapes of the letterforms.

Initials are ideal as the opening note of a chapter or special paragraph. They can be simple or profusely decorated, large or small, gilded or in intense heraldic colors. They are natural decorative elements: columns of text simply fall into place beneath them, and they subtly emphasize the underlying structure of the page. Initials are especially attractive on pages of uniform text "color."

Initials

Figs. 43/44

Bright heraldic colors and metals are the best accompaniment for pages of black lettering or type. Often a simple, undecorated initial exactly meets the requirement. The situation becomes challenging when several decorative titles must be placed at close intervals on the page, but this may also result in an especially imaginative solution with considerable movement and color. Lettering is a living thing—a constantly renewed symbol of human effort— a means of striving for spiritual and artistic fulfillment.

Figs. 52/53

A thorough study of old manuscripts strengthens your judgment, taste and sense of style; all of these are indispensable in the production of a personal manuscript book. Such a book will keep alive the traditions of past eras, and though it may be reproduced in an edition through offset printing, it will still be a hand-written creation.

The study of old manuscripts

The ideal manuscript book would be made by one person, acting as author, scribe, illuminator and binder. If the project is to be at all, the creator must love literature deeply; this will make him as happy in his performance of the work as the reader is in his reading of it. That is one of the most important concepts that I want to set forth in this volume: the scribe should always be deeply involved with what he writes.

The personal book

Complaints about the illegibility of hand-written texts and books often come from widely differing aptitudes in readers; this may be the result of habit, the hectic pace of modern life, the reader's being accustomed to seeing typeset matter, or also because he has no heartfelt connection with what he reads. All lettering styles must be legible—this is a basic principle of communication—

but there are times when legibility can become of secondary importance. Through certain "architectural" and graphic effects, the scribe can slow the reader's pace, making him that much more attentive to the content. In these cases, reduced legibility is fully justified.

Binding ornament in relief gold and color on white leather. 1939.

Write out the text in the sizes of lettering you expect to use, cut up the lines into individual strips, and then position them on a sheet of paper that is the same size and color as the one you'll use for the final project. If drawings will be part of the composition, make rough sketches in the sizes you anticipate using, cut them out and move them around until you find the best positions. This process usually requires several stages of design development, changing to a more compact or open layout, brightening things up with another size or style of lettering, or using a different color or line quality in the illustrations. This is the only way to evolve a design organically; by controlling each stage of its growth so that it remains a balanced whole. The goal is to create something that has visual and artistic unity and which therefore gives even stronger meaning to the text.

*Accent through color
contrast*

Good posture at the writing desk is very important: you will not be able to produce fine work unless you are comfortable and relaxed. The desk top can be flat or, if you prefer, at a slight angle. A flat surface permits letters of even density, while a slanted surface can make them uneven, since the ink tends to flow towards the bottoms of the letters as it dries. This is especially undesirable in work for reproduction, when gray areas may not photograph equally with blacks. Such changes in density will also mar the uniformity and rhythm of any piece that people will view as an original.
The ratio of seat height to desk height is also important. There is an optimum distance between eye and paper, and you must find this if you are to letter with freedom and certainty. Similarly, you should always direct your eyes straight ahead (perpendicular to the edge of the desk) and not off to the sides! Move the paper to and fro so that the word you are lettering is always directly in front of you and at a comfortable distance away from your stomach; if you leave the paper in one place and simply move your hand farther and farther to the right, your line of vision becomes increasingly oblique and soon you can no longer judge whether strokes are really vertical (or at an even slant, in the case of Italic).

MATERIALS – TECHNIQUES
Work table

For practice, use a fountain-pen ink that is as black and opaque as possible—this helps to define form and rhythm. Diluted to the proper strength, black watercolor also gives you good letters if you control the amount of fluid in the pen, (fill it with a brush touched to the underside, or if it is a reservoir pen, fill the reservoir only half-full). The best material is still ''Chinese ink'' in stick form, which you rub against a grinding stone containing a few drops of water; you can adjust the fluidity of this ink to perfectly match any surface— parchment, smooth paper or rough.

Inks and paints

69

High quality gouache (opaque water color) is best for colored lettering and decoration. Be sure to buy colors that have a high degree of permanence. Special occasions warrant "shell gold" and silver available from calligraphic suppliers. Water colors work well for most work, however.

PAPERS
Lettering tools

I always recommend that beginners write on smooth paper, at least at the outset. Large sheets of blue-gridded paper eliminate the need for ruling lines. Choose a letter size that is comfortable to write, as this frees you to think about the development of your own style and allows you to really feel the shapes of letters. Later on you can experiment to see how size and proportion affect the appearance of lettering. Each individual size and weight has its own special form and rhythm, and to create a harmonious overall design, you must make careful combinations of these.

Round-nibbed pen, broad pen, brush, quill, reed

Steel pens are the practical tools for this kind of work. Use round-nibbed pens (Redis, Mitchell Script, or Speedball "B" series) to write block letters; select a range from ¼ mm to 5 mm. Lettering with thicks and thins requires broad-edged pens (Brause, TO, Mitchell) in similar widths. If you are right-handed, use a pen whose nib edge is straight or cants down toward the right; left-handed scribes will find a left-cant pen more comfortable and can obtain very good results with it. Lettering is by no means impossible for the left-handed; it simply requires more work.

When you have begun to appreciate subtle differences in appearance and stroke weight, then it is time for you to cut your own pens. Turkey quills, bamboo and reeds are the most useful materials for small lettering. The width of a pen is always limited by the diameter of its shaft, because the underside of the nib must always be flat. In other words, a wide nib cut from a small shaft would have a concave shape and only its corners would be able to touch the paper. Therefore, to obtain a wide pen you must cut it from a large-diameter shaft. For the widest strokes, use good quality lettering brushes (available from sign-painting suppliers and some art stores) or cut a strip of the right shape from straight-grained softwood. I have had good results with pine, fir and spruce. One can make very clean thicks and thins with these if they are cut properly.

Custom-made pens are ideal personal equipment because they can be cut to match your own hand and work in total harmony with it. They respond to very slight pressure and can translate the subtlest of artistic sensations into visual form; these qualities make them perfect for use on the finest traditional materials (parchment, hand-made paper) since the extra flexibility in the pen will accommodate the characteristic rough surface of these materials.

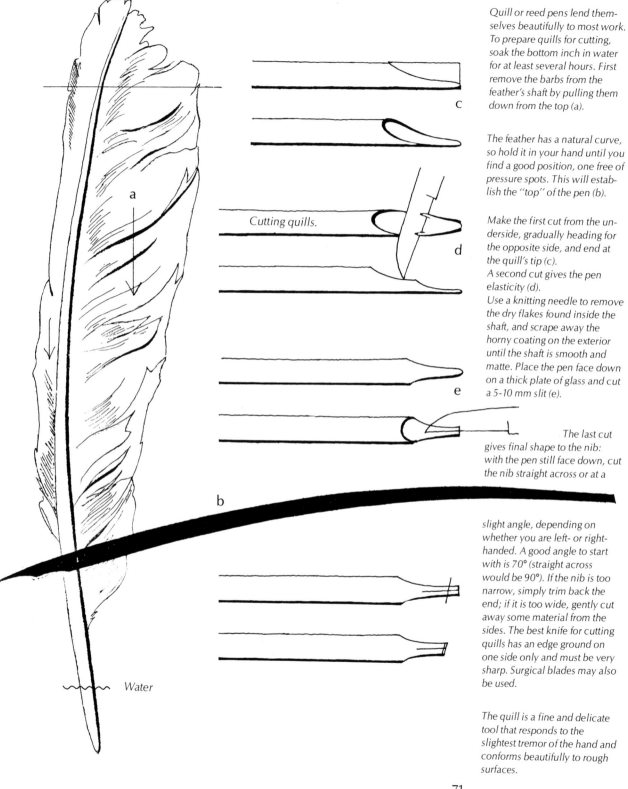

Quill or reed pens lend themselves beautifully to most work. To prepare quills for cutting, soak the bottom inch in water for at least several hours. First remove the barbs from the feather's shaft by pulling them down from the top (a).

The feather has a natural curve, so hold it in your hand until you find a good position, one free of pressure spots. This will establish the "top" of the pen (b).

Make the first cut from the underside, gradually heading for the opposite side, and end at the quill's tip (c).
A second cut gives the pen elasticity (d).
Use a knitting needle to remove the dry flakes found inside the shaft, and scrape away the horny coating on the exterior until the shaft is smooth and matte. Place the pen face down on a thick plate of glass and cut a 5-10 mm slit (e).

The last cut gives final shape to the nib: with the pen still face down, cut the nib straight across or at a slight angle, depending on whether you are left- or right-handed. A good angle to start with is 70° (straight across would be 90°). If the nib is too narrow, simply trim back the end; if it is too wide, gently cut away some material from the sides. The best knife for cutting quills has an edge ground on one side only and must be very sharp. Surgical blades may also be used.

The quill is a fine and delicate tool that responds to the slightest tremor of the hand and conforms beautifully to rough surfaces.

Cutting quills.

a

b

c

d

e

Water

Learn how to cut pens and then practice the technique thoroughly; I have included brief instructions and illustrations to help you begin. A fine, reliable tool is worth any amount of pain and attention to detail in its creation.

Paper selection
Grain direction

Machine-made papers have a definite "grain" or fiber direction, which affects how the paper folds and also how it reacts to gluing and mounting. A fold made against the grain will be brittle and uneven. If you leaf through a book containing sheets of paper thus folded, you will feel a sort of "resistance" in the flow of the pages. This diminishes the aesthetic pleasure of reading and touching a book.

Grain can also cause practical problems in bookbinding. Covers made from paper pasted onto boards will warp into a concave shape if the grain runs the wrong way, resulting in little or no protection for the pages. These mistakes are often made by people who attempt to reduce the amount of offcut (wasted paper) by running the grain the wrong way; such lack of care and thought will never result in a beautiful book. It is the designer's responsibility to remain in control at all times if he doesn't want an unpleasant surprise, and the only way he can do this is to tell the printer, at the outset, exactly what he wants and expects. This includes a discussion of page sizes based on the aesthetic and economic merits of what paper the printer has in stock and what he can order.

PARCHMENT

Parchment and vellum are animal skins that have been specially prepared and processed. Vellum (calfskin) has the best surface for lettering. Large skins often have a mottled or veined side which makes them suitable for one-sided pieces like diplomas, citations and other documents, while paler skins, which have been made more even on both sides, are the best material for books. Choose the appearance that is most compatible with your project. If your page size is relatively small, use a number of small skins rather than fewer large skins that will require folding—the larger the skin, the thicker and more

Figs. 30/41/62

difficult it is to fold and bind. All bindings must be sewn, to allow the natural "movement" of the parchment as it reacts to the atmosphere. Glue is not compatible with these skins and should be avoided.

The rarest skins of all are uterine vellum, obtained from unborn calves. These skins are almost as thin as cigarette paper and are often so translucent that they can only be used on one side.

The best materials for bookbinding are the rough and grainy skins of goats, sheep and (less frequently) pigs. The rough texture can create a beautiful contrast with the interior pages of the book, suggesting that the outer skin encloses and protects a precious and more vulnerable material within.

72

You can make colored skins with Brazil wood (for red tones) and logwood (for blue tones). Carbonate of potash is another possible source of blue color. The traditional purple is obtained with 5 parts red and 1 part blue. Soak shavings of each wood for 24 hours in separate containers of wine vinegar, add sufficient extra vinegar to make the required batch size, and boil until thick. Next, filter each color solution and make trial combinations in small quantities until you arrive at a good balance of color; then combine the full batches in this proportion. The trials are necessary because of the intensity of the blue dye and the fact that skins will vary in their absorption; start with the 5:1 mixture and vary it as you see fit. Use a wide brush to apply dye to the skin, covering the surface as evenly as possible, and repeat the process to get a darker shade. You can vary the final appearance from light to dark, faint color to strong. A deeper bluish-purple, approaching black, is made with 5 parts blue and approximately 1 part red.

Figs. 70/71

Fig. 42

Cut the skin to size before staining, but leave an extra border all around for stretching over a frame. Hold the skin to the frame with brads or pins, and then cut away the border when the skin is stained and dry. Also, degrease the skin before staining by rubbing it thoroughly with pumice and a wad of cotton wool.

Smooth paper with pre-printed grids is ideal for practice, but for careful work on fine paper, you must measure and rule all the lines yourself. Don't despair because of this! For me, there is a special kind of "tuning-in" process that happens while I am ruling lines or preparing vellum, and it helps to build my concentration. It is one last chance for me to review all the decisions that lead up to the present, and to ask if they are still valid. In addition, the process brings me to a state of heightened awareness at the time when I most need it: the beginning of final work. This beginning is always an adventure; the gift of a chance to do something new. It is a step into the unknown, made in awe, filled with the joy of discovery, a sense of duty to the written word, and the pleasant hope that the finished piece will be a success.

RULED LINES

On paper, rule lines with a sharp, hard pencil; make sure that the paper's surface can withstand erasures. Thin lines make it easy to get exact letter heights, but they may also leave undesirable grooves in the surface. You can leave ruled lines on the finished sheet if they don't conflict with the "architecture" of the lettering, and in some cases they may even enhance it.
On parchment and vellum, use a blunt needle to create grooves that become a part of the overall design. There are also times when lines of pale color are

a perfect complement to the lettering, acting more as structural and graphic elements than as guide lines. In such an instance, the letters would be freely written between the colored lines; this, however, is a technique best left to experienced scribes.

GILDING

Figs. 30/37/38/39/
42/56/64/70/71

There are two products used in the gilding of letters, and both are available from sign painting and/or calligraphic suppliers. "Shell gold" is real gold powder mixed with a binder (gum arabic or fish glue) and is sold as a tiny droplet or cake. It is used in all kinds of ornamental lettering. To apply it, dip a fine brush in water and then stir it against the gold until you have a thick pulp; use the brush to transfer a small amount to the underside of the pen; write a letter, taking care to make a good layer of gold. When dry, the gold letters will be firmly stuck to the sheet and can be made bright and shiny with a burnisher (usually made of agate). Polishing causes the powder to bind into little flat areas that reflect the light.

Figs. 36/37/38/
39/41/54/55

Burnishing

The second technique for working with gold is called "relief gilding." Write a few letters at a time with a pen and gilding size (gesso), the latter being dilute enough to flow through the pen but thick enough to provide a solid base for each letter. Immediately build up each letter with successive layers of thicker size, applying it with a brush. Speed is important here, because any letters that have a chance to dry between layers develop ridges and uneven contours, and these cannot be smoothed out later. Make only 5 to 10 letters at a time (depending on the humidity of the air) so that the size does not have a chance to dry out. When the letters are stiff but not too dry, polish them gently with a burnisher. To lay the gold leaf, breathe onto the size to re-moisten it and press on a layer of gold. You can transfer gold to the letters with tissue paper or with a brush, and the honey present in the size will hold it firmly in place. Has the gold stuck to all portions of the size? The only way to find out is to gently brush away the excess gold with a soft, dry brush. Polish the letters with a burnisher, beginning with extremely gentle movements and gradually increasing pressure until the matte surface of the gold becomes dark and shiny. This may be a tedious and suspenseful process, but it also can yield magnificent results. If the gold has not covered perfectly and brown spots show through (a frequent condition), simply breathe on the letter, apply another leaf of gold, and brush away the excess. Wait a bit and then burnish anew until the letter has no flaws. A frequent cause of brown spots is insufficient polishing of the size before the gold is laid, or allowing the size to dry out by waiting too long.

Gilding is usually difficult and complex for several reasons. You must have a spotlessly clean work area, without a trace of grease on the paper, the brush

or the tissue paper used to transfer the gold to the letterforms. For this reason, the tissue paper must be changed frequently. A certain amount of humidity in the air, from a damp day or nearby water sources, will help the process; when the air is too dry, the gilding will fail and no artificial means can save it. Once again the natural processes have proven to be the most successful.

Please note! Never lay relief gold on work that will be rolled up! The layers of size under the gold will peel away from the paper or skin! For these cases, shell gold is the only solution. In general, gilding technique is best learned in a short, concentrated stint; the materials are not cheap, and a failure at the early stages could discourage you from continuing if you allow too much time to elapse between practice sessions.

Warnings

Think about the specific effects that you want to create in your work; both red and green golds are available and project quite different moods. Leaf and shell gold can be obtained from specialty suppliers, and there are several recipes for formulating gilding gesso.

Leaf gold
Shell gold
Gesso

Monogram: FNV

30 *Baptismal prayer. 1957. Narrow, tight Roman letters with strong Gothic overtones, written with angled pen. Personal style of Roman caps written with flat pen, some letters in shell gold. On parchment with black ink and shell gold. Original size 16 x 29 cm.*

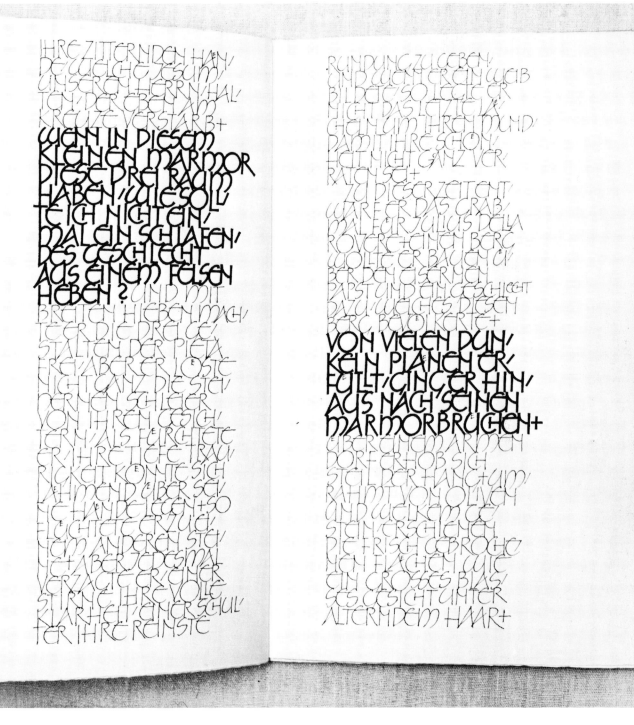

*31/32 Rainer Maria Rilke. From "Geschichten vom lieben Gott" ("Stories of the Beloved Father"). 1977.
Cover, title page and 2-page spread. Half-uncial, freely written without guidelines. Crow quill and square-nibbed pens.
Cover is embossed. Original size 20.5 x 31 cm.*

Friedrich Hölderlin

aus den Gedichten
und aus ‹Hyperion›

Ich sprach für alle

Verlag Neugebauer Press Bad Goisern

Ihr wandelt droben im Licht
auf weichem Boden, selige Genien!
Glänzende Götterlüfte
rühren euch leicht,
wie die Finger der Künstlerin
heilige Saiten.

Schicksallos, wie der schlafende
Säugling, atmen die Himmlischen,
keusch bewahrt
in bescheidener Knospe,
blühet ewig
ihnen der Geist,
und die seligen Augen
blicken in stiller
ewiger Klarheit.

Doch uns ist gegeben,
auf keiner Stätte zu ruhn,
es schwinden, es fallen
die leidenden Menschen
blindlings von einer
Stunde zur andern,
wie Wasser von Klippe
zu Klippe geworfen,
jahrlang ins Ungewisse hinab.

33/34
Friedrich Hölderlin.
Poems and excerpts from
"Hyperion." 1947. Title
page and interior page.
Personal, narrow Italic
with Gothic overtones,
written with angled pen.
Title page is red and
black, other page is green,
on hand-made paper.
Original size 22 x 35 cm.

35 Rainer Maria Rilke. "Die Weise von Liebe und Tod des Cornets Christoph Rilke" ("The Ballad of Christoph Rilke's Love and Death"). 1936-37. Fraktur text written with angled pen. Lettering and brush illustration in shell gold and silver on purple parchment. Floral accents in color. Original size 44 x 20 cm.

36 Friedrich Neugebauer. Poem to celebrate a 21st birthday. 1948. Free arrangement of Gothic text with Fraktur capitals, written with angled pen on parchment. Illustration in watercolor and relief gold. Original size 15 x 23 cm.

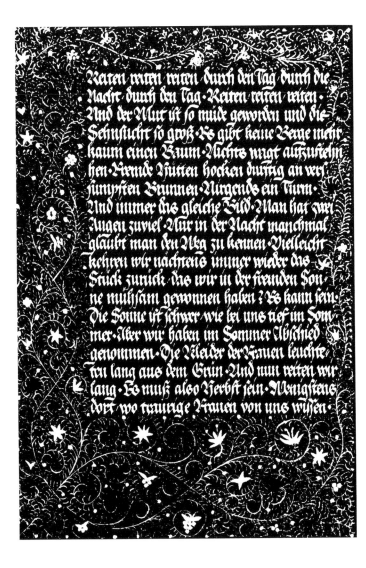

Es blüht
eine Blume,
gar lieblich und rein
sie blühet in Liebe
voll Pracht - ihr Herzchen,
Es muß von purem Golde sein,
wie zieht's mich zu ihr hin
mit Macht!
Die Vöglein, die Bienen,
die Falter - und ich,
wir singen und summen ihr Ehr,
Gott Vater, im Himmel,
erhalte uns Dich,
wir lieben Dich alle
gar sehr!

Zum
21. Geburtstag

A hAll in CApuLeTs
HOUSE

Romeo to a Servingman

What lady's that / which doth enrich the hand
Of yonder knight ?

Servingman I know not / sir ·

Romeo O / she doth teach the torches to burn bright !
It seems she hangs upon the cheek of night
Like a rich jewel in an Ethiop's ear ·/
Beauty too rich for use / for earth too dear !
So shows a snowy dove trooping with crows /
As yonder lady o'er her fellows shows ·
The measure done I'll watch her place of stand /
And / touching hers / make blessed my rude hand ·
Did my heart love till now ? forswear it / sight !
For I ne'er saw true beauty till this night ·

Romeo to Juliet

F I PROFA'
NE WITH
MY UNWOR'
THIEST hand

This holy shrine / the gentle fine is this /
My lips / two blushing pilgrims / ready stand
To smooth that rough touch with a tender kiss ·

Juliet Good pilgrim / you do wrong your hand too much /
Which mannerly devotion shows in this ·/
For saints have hands that pilgrims' hands do touch /
And palm to palm is holy palmers' kiss ·

Romeo Have not saints lips / and holy palmers too ?

Juliet Ay / pilgrim / lips that they must use in prayer ·

Romeo O / then / dear saint / let lips do what hands do ·/
They pray / grant thou / lest faith turn to despair ·

CAPULETS ORCHARD

Enter Romeo

Romeo E jefts at fcars that never felt a wound·

Juliet appears above at a window

But·fofr! what light through yonder window breaks?
It is the eaft·and Juliet is the fun!
Arife·fair fun·and kill the envious moon·
Who is already fick and pale with grief·
That thou her maid art far more fair than fhe·
Be not her maid·fince fhe is envious·
Her vefial livery is but fick and green·
And none but fools do wear it·caft it off·
It is my lady·O·it is my love!
O·that fhe knew fhe were!
She fpeaks·yet fhe fays nothing: what of that?
Her eye difcourfes·I will anfwer it·
I am too bold·'tis not to me fhe fpeaks:
Two of the faireft ftars in all the heaven·
Having fome bufiness·do intreat her eyes
To twinkle in their fpheres till they return·
What if her eyes were there·they in her head?
The brightness of her cheek would fhame thofe ftars·
As daylight doth a lamp·her eyes in heaven
Would through the airy region ftream fo bright
That birds would fing and think it were not night·
See·how fhe leans her cheek upon her hand!
O·that I were a glove upon that hand·
That I might touch that cheek!

Juliet Ay me!

Romeo She fpeaks:

O·fpeak again·bright angel! for thou art
As glorious to this night·being o'er my head·
As is a winged meffenger of heaven

37/38/39 William Shakespeare. Four love scenes from "Romeo and Juliet." 1938-39. Headings in Roman caps, flat pen. Text in Half-uncial and Italic, angled pen. Illumination and initial caps in relief gold, shell gold and watercolor. On parchment. Original size 40 x 60 cm.

Will I ſet up my everlaſting reſt,
And ſhake the yoke of inauſpicious ſtars
From this world-wearied fleſh. Eyes, look your laſt !
Arms, take your laſt embrace ! and, lips, O you
The doors of breath, ſeal with a righteous kiss
A dateless bargain to engroſſing death !
Come, bitter conduct, come, unſavoury guide !
Thou deſperate pilot, now at once run on
The daſhing rocks thy ſea-ſick weary bark.
Here's to my love ! *Drinks* O true apothecary !
Thy drugs are quick. Thus with a kiss I die. *Dies*

<center>*Juliet wakes*</center>

Juliet O comfortable friar ! where is my lord ?
I do remember well where I ſhould be,
And there I am : where is my Romeo ?
What's here ? a cup, cloſed in my true love's hand ?
Poiſon, I ſee hath been his timeless end :
O churl ! drunk all, and left no friendly drop
To help me after ? I will kiss thy lips,
Haply ſome poiſon yet doth hang on them,
To make me die with a reſtorative.

<center>*Kiſſes him*</center>

Thy lips are warm.

Hea, noiſe ? then I'll be brief. O happy dagger !
Snatching Romeo's dagger
This is thy ſheath, *Stabs herſelf*, there ruſt, and let me die.
Falls on Romeo's body, and dies.

Enter ſome of the Watch, with the Prince and
Attendants, Capulets, Montagues and others.

40 Johann Wolfgang von Goethe. Excerpt from "Urfaust." 1937. Personal style of Fraktur, written with angled pen on parchment. Original size 16 x 27 cm.

war und sagte zu Doktor Fausto: Die Antwort bring ich dir und Antwort mußt du mir geben. Doch will ich zuvor hören was dein Begehr sei dieweil du mir auferlegt hast auf diese Zeit zu erscheinen. Dem gab Doktor Faustus Antwort jedoch unrecht und seiner Seelen schädlich denn sein Sinn stund anders nicht denn daß er kein Mensch möchte sein sondern ein leibhaftiger Teufel oder ein Glied davon und begehrte vom Geist wie folgt: Erstlich daß er Fräuschlichkeit Form und Gestalt eines Geistes möchte an sich haben und bekommen. Zum andern daß der Geist alles das tun solle was er begehrt und von ihm haben wolle. Zum dritten daß er ihm geflissentlich untertänig und gehorsam sein wolle als ein Diener. Zum vierten daß er sich allezeit so oft er ihn fordert und berufe in seinem Haus solle finden lassen. Zum fünften daß er in seinem Hause unsichtbar regiere und sich sonsten von niemand als von ihm sehen lasse er sei denn sein Wille und Geheiß. Und letzlich daß er ihm so oft er ihn fordert und in der Gestalt so er ihm auferlegen würde erscheinen

Fausts Geburt und Erziehung

Doktor Faustus ist eines Bauern Sohn gewesen zu Rod bei Weimar gebürtig der zu Wittenberg eine große Verwandschaft gehabt. Seine Eltern waren gottselige und christliche Leut und sein Oheim der ein vermögender Bürger zu Wittenberg gewesen hat Doktor Fausten aufgezogen und gehalten wie sein Kind. Denn dieweil er ohne Erben war nahm er diesen Faustum zu einem Kind und Erben auf ließ ihn auch in die Schul gehen die Theologie zu studieren. Er aber ist von diesem gottseligen Fürnehmen abgetreten und hat Gottes Wort mißbraucht. Derhalben wir solche Eltern und Freunde die gern alles Gute und das Beste gesehen hätten wie solches alle frommen Eltern gern sehen ohne Tadel sein lassen und sie in diese Geschichte nicht mischen wollen so haben auch seine Eltern dieses gottlosen Kindes Greuel nicht erlebt noch gesehen. Da Doktor Faust als ein ganz gelehriger und geschwinder Kopf zum

41 Rudolf von Larisch.
Maxim ("The artist needs
lettering – Lettering needs
the artist"). Roman capitals
in relief gold on parchment.
Natural shape of skin has
been retained.
Original size 12 x 31 cm.

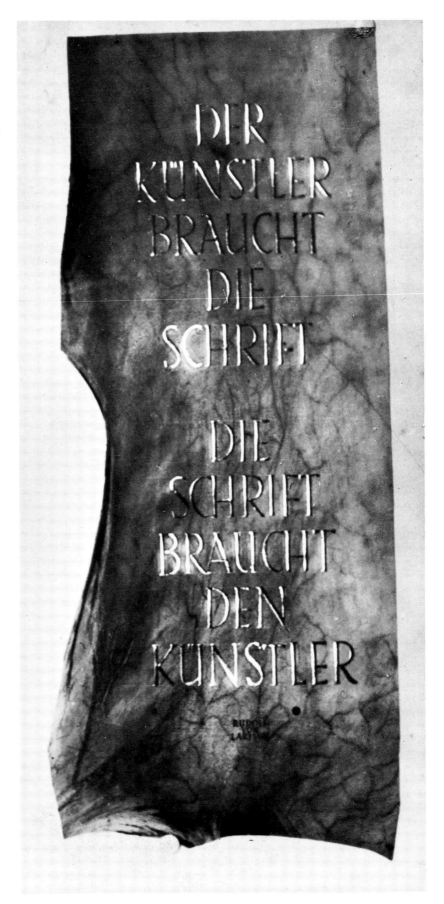

42 *"The Song of Solomon." 1936. German text in Fraktur, written with angled pen. Hebrew text written with specially-cut nib. Shell silver letters on black parchment. Scrolls are made of ebony. Original size 250 x 30 cm.*

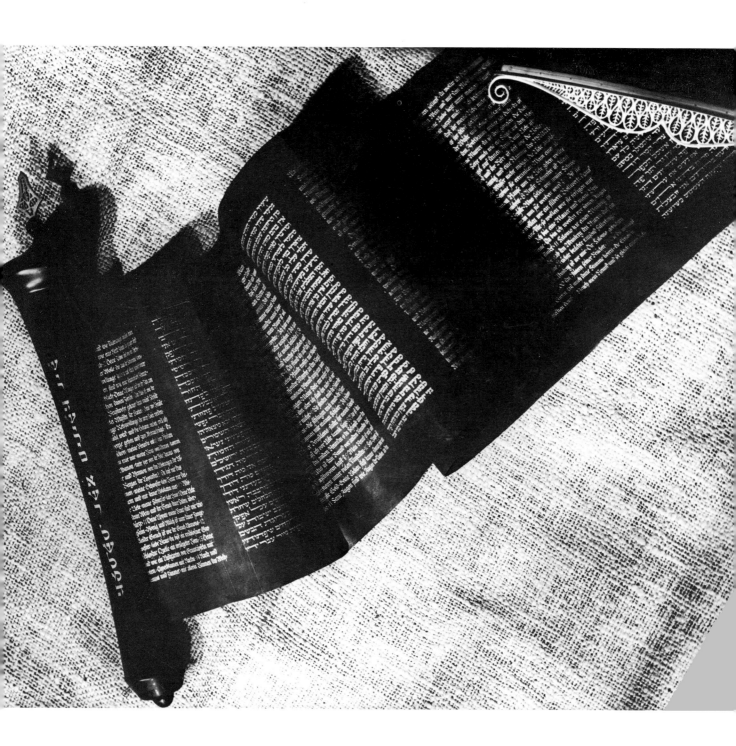

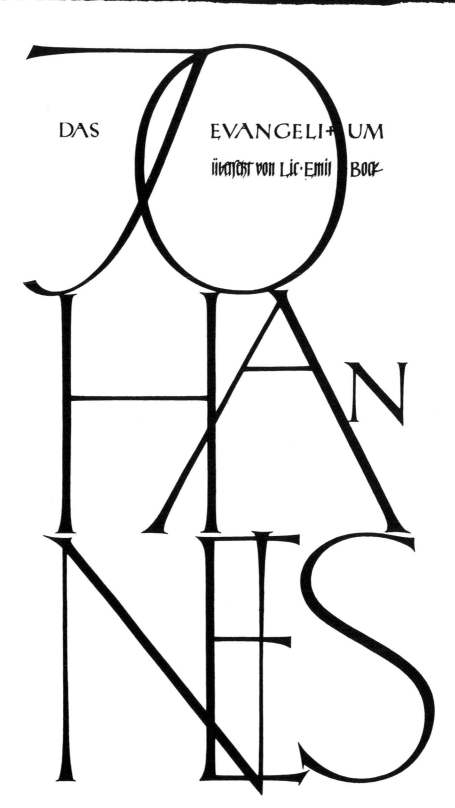

DAS EVANGELI+UM

übersetzt von Lic·Emil Bock

JOHANNES

43/44 Lic. Emil Bock. (''The Gospel According to John''). 1947-1957. Hand-written book on hand-made paper. Title and 2-page spread. Roman capitals, flat pen; personal style of condensed Roman letters, angled pen. Black text with red and silver accents. Original size 22 x 34 cm.

PROLOG
+DES EVANGELISTEN

IM URBEGINNE WAR DAS WORT

UND EIN GÖTTLICHES WESEN

WAR DAS WORT·

UND DAS WORT WAR SCHAF·

FEND BEI GOTT/

DIESES WAR IM URBEGINNE

SCHAFFEND BEI GOTT·DURCH

ES SIND ALLE DINGE GEWOR/

DEN/UND NICHTS VON ALLEM

ENTSTANDENEN IST ANDERS

ALS DURCH DAS WORT GE/

WORDEN·

IN IHM WAR DAS LEBEN/UND

20.Kapitel

45 Gertrud Fussenegger. "Sprache" ("Speech"). 1974. Poem on accordion-folded paper, bound into a hard cover. Roman written with angled pen. Forms of "f" and long "s" are in opposition to the rhythm of the text and echo the subject of the poem. White letters on black background. "Bibliophile Bändchen" series. Original size 23 x 100 cm.

Noch nicht Gedachtes
war da·
Spiel begann,
warf mit Bällen
und wenn fie hüpften,
fchlug man die Schenkel,
wiegte fich hin und her·
Das war das Lied·

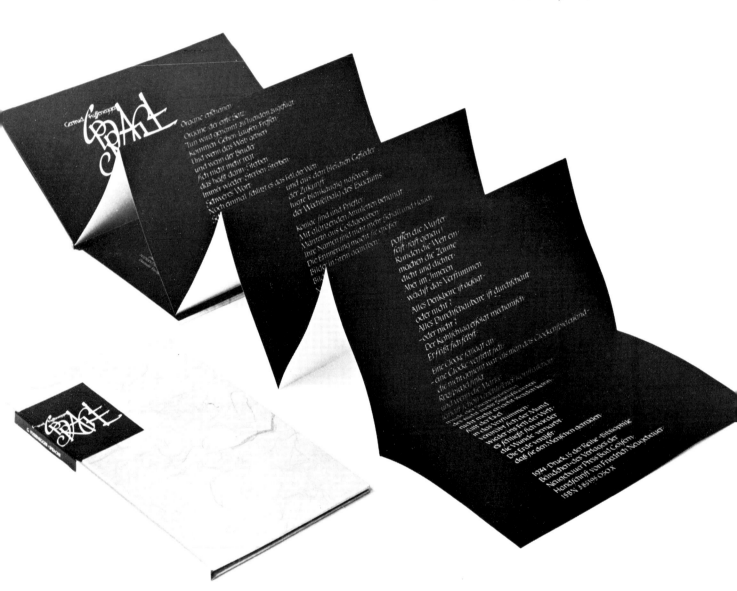

46 *Richard Billinger. "Breughel." 1974. Poem on
accordion-folded paper, bound into a hard cover.
Personal style of condensed Roman with Gothic
overtones, angled pen. Black letters on green paper.
"Bibliophile Bändchen" series.
Original size 23 x 100 cm.*

Komme aus der Stadt gezogen,
hab dem Weib mein Herz verlogen,
seh an eines Waldes Tümpel
noch die Binsen wintergrünen,
kenn der Knechte Stundenschläge,
laufe mondgeweihte Wege,
sitze mild und wild auf Bänken
lärmgefüllter Säuferschenken.

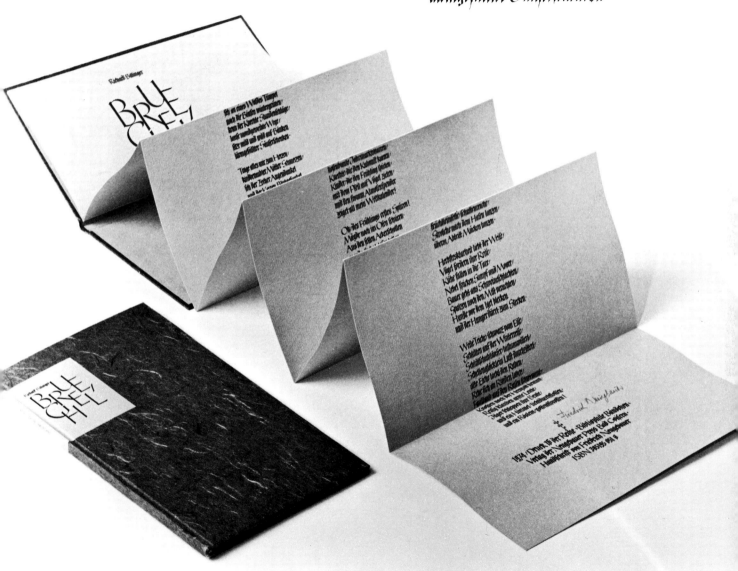

47 *"The 4 Elements."*
Anniversary publication
of an export firm. 1960.
Original size 30 x 30 cm.

DIE **4** ELEMENTE

BEDEUTEN DAS MASS·
SIE SIND GLEICHSAM DIE
ÄUSSERE WELT/AN DER WIR
TEILHABEN UND DIE WIR
VON INNEN GESTALTEN MÜSSEN·
FINDEN WIR DAS GÜLTIGE
MASS IHRER ORDNUNG/SO
SCHAFFEN WIR MIT GLEICHEM
GEISTE UND WERDEN DARIN
SCHÖPFERISCHE MENSCHEN·

an einem kleinen Beispiel dürfen wir erläutern¹

Als ich davonging

In der Weihnachtswoche des Jahres 1864 hatten wir, mein Meister und ich, weit drinnen in einem Grabenhäusel der St. Kathreinpfarre auf der Ster gearbeitet, um den armen Leuten, die schon seit Michaeli her in ihrem Linnengewand froren, endlich für den Winter neue Lodenkleider zu machen. Es hatte die Tage arg geschneit und gestürmt, so daß ich insgeheim schon in großer Angst war, wir wären eingeweht und würden über die Feiertage in der ödweiligen, rauchenden Hütte verbleiben müssen. Schrecklicheres als das hätte ich mir nicht denken können; meine Hoffnung und Sehnsucht das Jahr über waren die lieben Weihnachten mit ihrer Weihe im Heimathaus, mit ihrer Glorie in der Kirche, mit ihrem Festmahl und mit ihrer hübschen Reihe von Feiertagen. Da konnte ich bei meinen Büchern, Schriften und Zeichnungen sein. Ich konnte mir nun Schreibzeug kaufen, denn so außerordentlich hatte sich meine Lage gebessert, seit es Wochenlohn gab.

Es standen fröhliche Weihnachten bevor, und ich machte mir an den langen Winterabenden bei Nadel und Zwirn im stillen manchen Plan für Erzählungen, Gedichte, Dramen und so weiter, die ich in den Feiertagen beim Ofen und bei der Fackel daheim ausarbeiten wollte.

Und wenn wir dann spät um zehn oder gar um elf Uhr — bei dringender Arbeit vor Festtagen mußten wir stets tief in die Nacht hinein fleißig sein — aufs Stroh gingen, das uns die Bäuerin auf dem Fußboden in der Stube nahe an unserem Arbeitstisch ausgebreitet hatte, betete ich, daß die Witterung sich zum Guten wende.

Ein frischer Wind, ein heiterer Himmel, gute trockene Kälte, hie und da ein Schneeschaufler — so war der Heilige Abend. Mittags um elf Uhr sagte der Meister: „So, jetzt machen wir Feierabend." Ich zog die Fäden aus den Nadeln, steckte die Nadeln in das Kissen und das Kissen in das Ränzel; die Schere, den Pfriemen, den Fingerhut dazu, fröhlich pfeifend, wie allemal zur Feierabendzeit — wie hätte ich wissen können, daß es das letztemal war?

18

Mut des Schwachen, Milde des Starken — beide anbetungswürdig.

Der Künstler versäume nie, die Spuren des Schweißes zu verwischen, den sein Werk gekostet hat. Sichtbare Mühe ist zuwenig Mühe.

Die Herrschaft über den Augenblick ist die Herrschaft über das Leben.

Man darf die Phantasie verführen, aber Gewalt darf man ihr nicht antun wollen.

Nicht tödlich, aber unheilbar, das sind die schlimmsten Krankheiten.

Kein Mensch steht so hoch, daß er anderen gegenüber nur gerecht sein dürfte.

Der Umgang mit einem Egoisten ist darum so verderblich, weil die Notwehr uns allmählich zwingt, in seinen Fehler zu verfallen.

Es gehört weniger Mut dazu, der allein Tadelnde als der allein Lobende zu sein.

Wenn die Zeit kommt, in der man könnte, ist die vorüber, in der man kann.

Das gibt sich, sagen schwache Eltern von den Fehlern ihrer Kinder. O nein, es gibt sich nicht, es entwickelt sich!

18

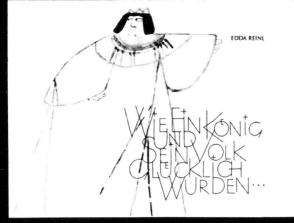

EDDA REINL

WIE EIN KÖNIG UND SEIN VOLK GLÜCKLICH WURDEN...

Salzburger Sträußchen

Marie de Posz
Alfred Baur

Edition Neugebauer

im Hermann Schroedel Verlag

Angelika Kaufmann

DAS EIN SAME SCHAF

Verlag der Neugebauer Press
Bad Goisern

Marie-José Sacré — Colette Demez
Deutsche Bearbeitung des Textes:
Lois-Wolfgang Neuper

ALS ES NICHT MEHR REGNETE...

Edition Neugebauer im
Hermann Schroedel Verlag

EDDA REINL
RIRI
IM FARBEN
LAND
L.W. NEUPER

BILDERBUCH-STUDIO
NEUGEBAUER
BAD GOISERN

ORDINATION
Doktor MAUS

INGRID OLDEN FÜR MONIKA

Edda Reinl

Die kleine Schlange

Verlag der Neugebauer Press Bad Goisern

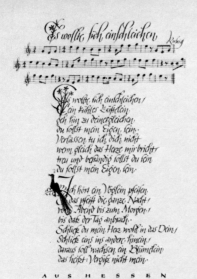
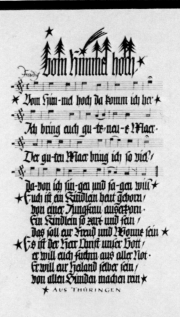

Preceding page:

51 "Lieder und Weisen aus deutschen Landen" ("Songs and Sayings from German-speaking Countries"). Two-page spreads from a collection of folk songs. Written in prison camp in Egypt, 1944-47. Fraktur, Half-uncial, Italic and Gothic written with angled pen. Place names (bottom lines) written with flat pen. Music notation in colors to act as a decorative element. Original size 33 x 20.5 cm.

52 "All mein Gedanken" ("All My Thoughts"). Egypt, 1944-47. Two page spread. Gothic text with Roman and Fraktur caps, angled pen. Bottom titles in Roman caps, flat pen. Initial on right-hand page is in red and blue, and counterbalances the six lines of Gothic text below. Original size 34 x 22 cm.

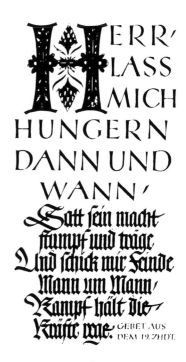

53 "Lieder und Weisen aus deutschen Landen." Egypt, 1944-47. Title page from the collection of folk songs, written in Fraktur and Roman caps. Illumination in watercolor. Original size 33 x 20.5 cm.

Lieder
und
Weisen
aus
deutschen
Landen

GESUNGEN IN KRIEGSGEFANGENSCHAFT
1944 - 1946

DE
PROCESSIONE
IN FESTO
CORPORIS
CHRISTI

MATTHAEVS

MARCVS

LVCAS

JOANNES

LIBER
GENERATIONIS
JESU CHRISTI FILII DAVID

filii Abraham · Abraham genuit Isaac · Isaac au
tem genuit Jacob · Jacob autem genuit Judam et
fratres ejus · Judas autem genuit Phares et Zaram
de Thamar · Phares autem genuit Esron · Esron au
tem genuit Aram · Aram autem genuit Aminadab ·
Aminadab autem genuit Naasson · Naasson autem
genuit Salmon · Salmon autem genuit Booz de
Rahab · Booz autem genuit Obed er Ruth · Obed
autem genuit Jesse · Jesse autem genuit David regem ·
David autem genuit rex Salomonem er ea quae fu
it Uriae · Salomon autem genuit Roboam · Roboam
autem genuit Abiam · Abias autem genuit Asa ·
Asa autem genuit Josaphat · Josaphat autem ge
nuit Joram · Joram autem genuit Oziam · Ozias
autem genuit Joatham · Joatham autem genuit Achaz ·
Achaz autem genuit Ezechiam · Ezechias autem ge
nuit Manassen · Manasses autem genuit Amon ·
Amon autem genuit Josiam · Josias autem genuit
Jechoniam et fratres ejus in transmigratione Ba
bylonis · Et post transmigrationem Babylonis:
Jechonias genuit Salathiel · Salathiel autem ge
nuit Zorobabel · Zorobabel autem genuit Abiud ·
Abiud autem genuit Eliacim · Eliacim autem genu
it Azor · Azor autem genuit Sadoc · Sadoc autem
genuit Achim · Achim autem genuit Eliud · Eliud
autem genuit Eleazar · Eleazar autem genuit Ma
than · Mathan autem genuit Jacob · Jacob autem

54/55 "Fronleich-
nams-Messbuch"
("Corpus-Christi Missal").
1937. Text in Fraktur,
written with angled pen.
Titles in Roman, relief
gold applied over letters
written with flat pen.
Black and gold on
parchment.
Original size 22 x 36 cm.

56 *"Schlaflied für Monika" ("Lullabye for Monika"). Lyrics and melody from Kurt Ehni. 1942. Written on parchment, Italic text and Gothic title, angled pen. Second line ("Für Monika") written with flat pen; notes done with square pen. Watercolor and shell gold. Sewn decoration at edges. Original size of double spread 19.5 x 11.5 cm.*

57 *"Prolog nach Johannes" ("The Gospel According to John"). Illustrations by Ernst Degasperi. 1974. Title page. Roman caps written with flat pen. Green lettering with silver-and-gold illustration. From the "Graphik Studio" series. Original size 35 x 35 cm.*

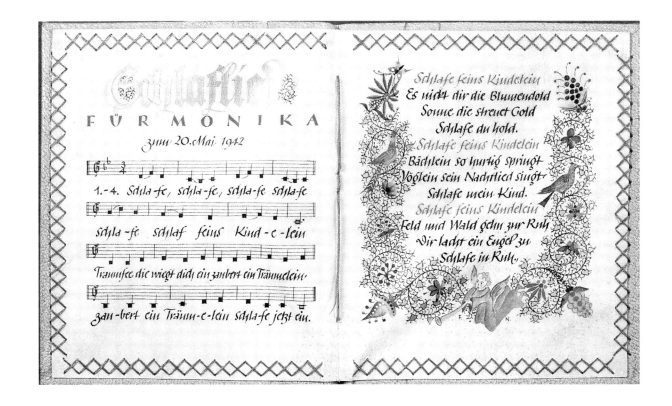

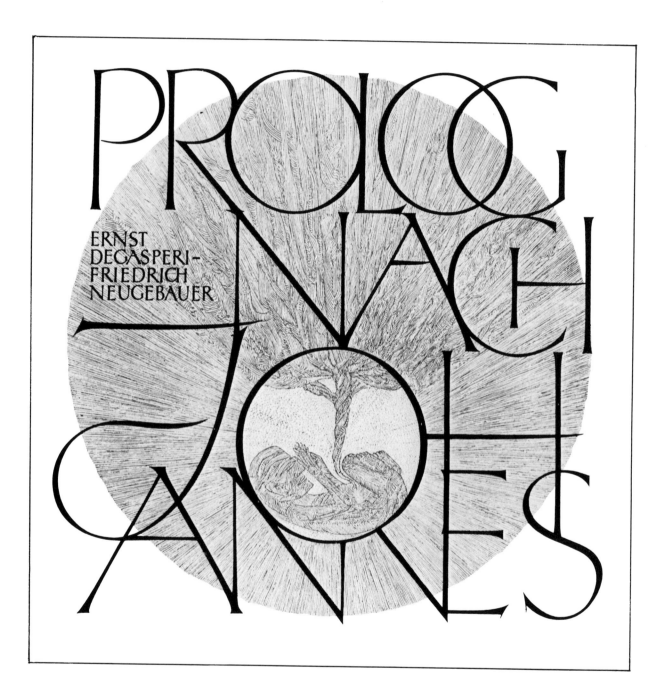

PROLOG NACH JOHANNES

ERNST
DEGASPERI –
FRIEDRICH
NEUGEBAUER

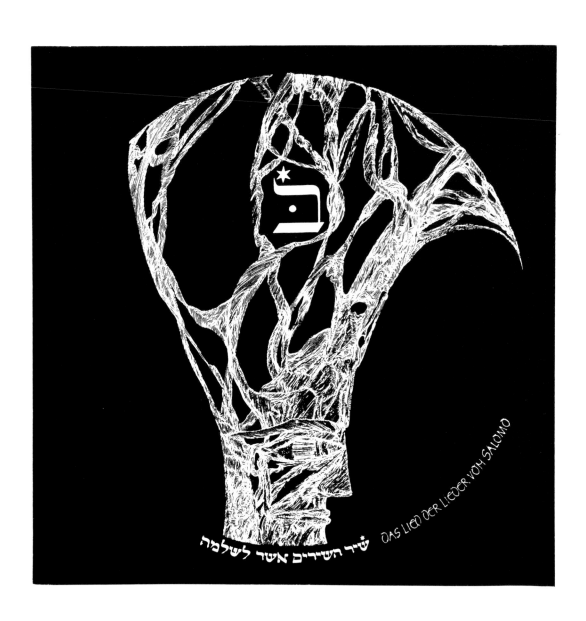

שיר השירים אשר לשלמה

DAS LIED DER LIEDER VOM SALOMO

אני חבצלת השרון שושנת העמקים:
כשושנה בין החוחים כן רעיתי בין הבנות:
כתפוח בעצי היער כן דודי בין הבנים בצלו חמדתי
וישבתי ופריו מתוק לחכי:
הביאני אל-בית הין ודגלו עלי אהבה:
סמכוני באשישות רפדוני בתפוחים כי-חולת אהבה אני:
שמאלו תחת לראשי וימינו תחבקני:
השבעתי אתכם בנות ירושלם בצבאות או באלות השדה אם-תעירו
ואם-תעוררו את-האהבה עד שתחפץ:

HL2/1-7

Zwiegespräch der Geliebten / Jch bin die Narzisse von Saroh / die Lilie der Taler !

Wie die Lilie unter den Disteln / so meine Freundin unter den Mädchen !

Wie unter den Waldesbäumen der Apfelbaum / so mein Geliebter unter den Burschen

Jn seinem Schatten / so heiss begehrt / will ich sitzen / und süss

schmeckt seine Frucht meinem Gaumen.

Er führt mich ins Haus des Weines / sein Banner über mir ist die Liebe.

Helft mir auf mit Traubenkuchen / erfrischt mich mit Äpfeln / denn ich bin krank vor Liebe !

Seine Linke fasst unter mein Haupt / seine Rechte empfängt mich

Jch beschwöre euch Jerusalems Töchter /

Bei den Gazellen oder den Hindinnen der Flur / stört doch die Liebe nicht /

und weckt sie nicht auf / bis es ihr selbst gefällt !

58/59 "Das Lied der Lieder" ("The Song of Songs"). Illustrations by Ernst Degasperi. 1969. Original text in Hebrew moves from right to left in opposition to the German text, creating a shape perfectly complementary to the illustration. Hebrew lettering with specially-cut nib, German text in Half-uncial with pointed quill. Black lettering, illustrations in gray and black. From the "Graphik Studio" series. Original size 35 x 35 cm.

60/61 Cover designs for books, using
lettering, drawings and typography. 1938-1975.
For Neugebauer Press and for other publishers.

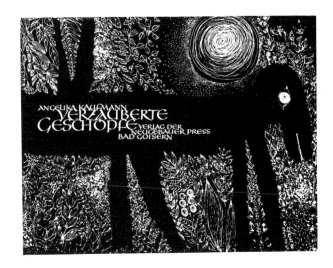

Thomas Mann
KÖNIGLICHE
HOHEIT
Roman

BERMANN·FISCHER ROMAN·BIBLIOTHEK

NELLY SACHS ✦ STERNVERDUNKELUNG ✦ GEDICHTE

STERN
VER
DUNKE
LUNG
Nelly Sachs
GEDICHTE

MAN
MUSS
DAS
GUTE
TUN

MARIE VON EBNER-ESCHENBACH
Aphorismen

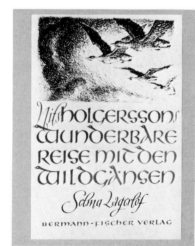

NILS HOLGERSSONS
WUNDERBARE
REISE MIT DEN
WILDGÄNSEN

Selma Lagerlöf

BERMANN-FISCHER VERLAG

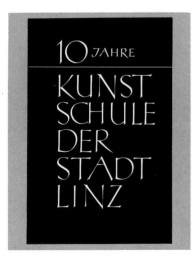

10 JAHRE
KUNST
SCHULE
DER
STADT
LINZ

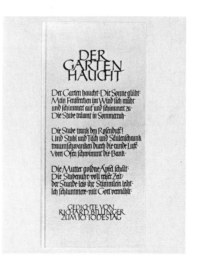

DER
GARTEN
HAUCHT

Der Garten haucht. Die Sonne glüht.
Mein Fenstterlein im Wind sich müht
und schimmert auf und schimmert zu.
Die Stube träumt in Sommerruh.

Die Stube trank den Rosenduft!
Und Stuhl und Tisch und Säulenschrank
traumschwanken durch die raue Luft.
Vom Ofen schwimmt die Bank.

Die Mutter goldne Äpfel schält.
Die Stubenuhr voll weiser Zeit
der Stunde leis ihr Stimmlein leiht.
Ich schlummere mit Gott vermählt.

GEDICHTE VON
RICHARD BILLINGER
ZUM 10. TODESTAG

ELSE GIORDANI

DIE
LINZER
HAFNER
OFFIZIN

62 Certificate to commemorate the laying of the corner-stone for a new concert hall. 1969.

63 Diplomas and certificates designed and lettered for the Austrian Chamber of Commerce. 1952-53.

Die Bundeskammer der gewerblichen Wirtschaft beurkundet hiemit, daß Herrn

GEORG PACHER

Direktor der Zellwolle A·G· in Lenzing/Oberösterreich in Anerkennung seiner ganz hervorragenden Verdienste um die österreichische Wirtschaft die GOLDENE EHRENMEDAILLE verliehen wurde.

Wien, am 27. Oktober 1952

BUNDESKAMMER DER GEWERBLICHEN WIRTSCHAFT

DER GENERALSEKRETÄR:
Dr. Thalhammer

DER PRÄSIDENT:
A. W. Pithus

Die Kammer der gewerblichen Wirtschaft für Oberösterreich beurkundet hiemit, daß

Herr Ludwig Unterberger, Maschinmeister, in Anerkennung einer ununterbrochen 25 jährigen treuen und zufriedenstellenden Dienstleistung im Betriebe Demokratische Druck- und Verlagsgesellschaft in Linz die bronzene Mitarbeiter-Medaille verliehen wurde. Linz, am 24. August 1951

Die Kammer der gewerblichen Wirtschaft für Oberösterreich

DER PRÄSIDENT DER KAMMERAMTSDIREKTOR

DIE KAMMER DER GEWERBLICHEN WIRTSCHAFT FÜR OBERÖSTERREICH

beurkundet hiemit, daß Herrn

JOHANN BAUMGARTER

Inh. d. Kleinmünchner Spinnereien für die bei der Gewerbe-Industrie-u-Handel-Schau Steyr 1951 gezeigten Leistungen die GOLDENE AUSSTELLUNGSMEDAILLE verliehen wurde.

Linz, am 9. September 1953

DIE KAMMER DER GEWERBLICHEN WIRTSCHAFT FÜR OBERÖSTERREICH

N

DER PRÄSIDENT: DER KAMMERAMTS-DIREKTOR:

Meisterbrief

FRIEDRICH GRILLMEYER, GEBOREN AM 24·MÄRZ 1926 IN SCHÄRDING I· HAT VOR DER MEISTERPRÜFUNGSKOMMISSION DER KAMMER DER GEWERBLICHEN WIRTSCHAFT FÜR OBERÖSTERREICH DIE MEISTER-PRÜFUNG IM BUCHBINDERHANDWERK ABGELEGT UND DAMIT DAS RECHT ERWORBEN, DEN MEISTERTITEL ZU FÜHREN UND LEHRLINGE ZU HALTEN · LINZ/DONAU, AM 18·SEPTEMBER 1953 DIE KAMMER D·GEWERBLICHEN WIRTSCHAFT FÜR OBERÖSTERREICH

DER PRÄSIDENT: DER KAMMERAMTSDIREKTOR: N

64 *City map of Vienna. 1936-37. Drawn and lettered on a full, untrimmed calfskin. Principal landmarks shown in their locations. District coats of arms in heraldic colors. Shell gold and silver decorations. Seal of Vienna attached to skin. Original size 85 x 72 cm.*

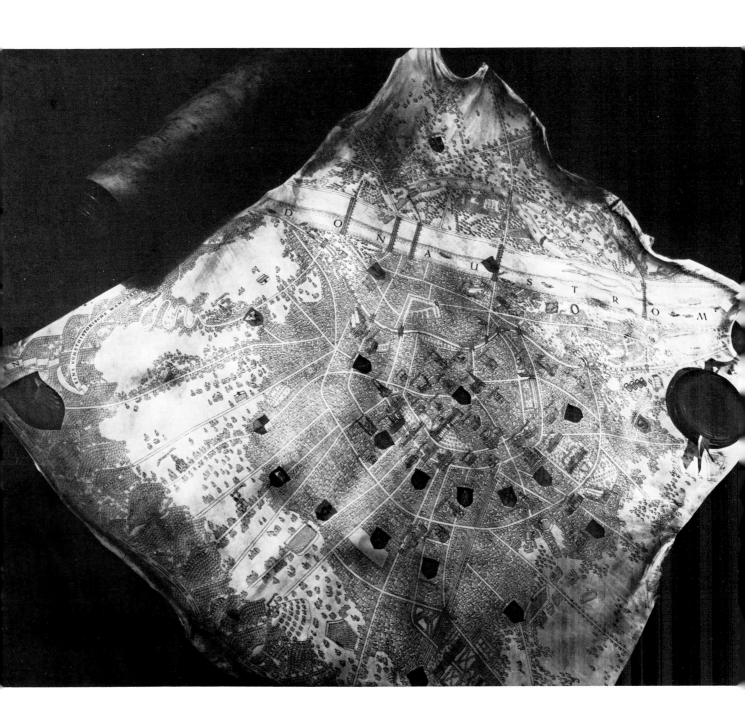

Dear Friedrich:

I don't know how to thank you for your beautiful gift of Shakespeare Sonnet 15. I was overwhelmed. Anne Englund, whom I've been visiting at the Carmelite Monastery, was also. Anne is very happy in her new life and I keep her informed as to what is happening at the Library and other things of interest in the outside world. Everyone misses her so, so much but the nuns (~~with~~ including Anne there are 17 at the Monastery) are overjoyed to have her with them. She is doing much practice with calligraphy and several of her 'sisters' are interested. Anne and I are helping. I'm taking them books and calligraphy supplies and one of our leading scribes* is going up to the Monastery to give lessons. Anne's calligraphy is developing by leaps and bounds.

As for myself.. I've been very busy with commercial calligraphy —busier than I've ever, ever been but have done a few things for the Monastery.

I'm writing Michael about the FABLES - He will let you know of how things stand this end.

Love & all best wishes for 1978,

Richard

* Alan Blackman

I don't think we can ever express totally, how much we enjoyed the workshop & the visit, as well as all of your efforts on our behalf. How can we ever repay you? It all was a glorious experience that touched our lives immensely & we thank you from the bottom of our hearts! Larry will write to you soon in German & he will be able to say it better than I! Chris, too plans a letter, but 13 year olds are harder to hold down and say their Thank You's! He is making use of BLOCK LETTERING in some School projects & has been pleased with himself!

Larry plans an article for the Los Angeles Society for Calligraphy newsletter, on the workshop & our experiences, & we will send copies - Hopefully they will not fool with it, as they tend to do. In addition, we have been asked to present a program on our experiences 'ala' Neugebauer, for the group, so we hope that doesn't change. Larry has some marvelous slides of our working situation, & with the work to show, some board demonstrations & lecture

Dear Mr Neugebauer, Greetings! I hope everything is going well for you and your family. I understand last years workshop with the American students was quite successful. I think it is wonderful that your influence is being felt over here.

In that respect, I would like to tell you about a book I am presently working on for T B W Books of Woolwich, Maine. This book will contain a collection of title pages employing the effective use of calligraphy and lettering (either in total or mixed with type). This collection will be preceded with an account of the work done during the first part of the century when, once again, skilful artists/ calligraphers placed their talents at the service of the printed book.

For the collection I want to show the work of international designers rich in the tradition of letters

68 Letterheads. Calligraphy as an applied art.

Top left, for an art school:
2-color design, handlettered.
Top center, for a city planner:
black lettering with halftone
map in contrasting color.
Top right, for a hardware store:
pen strokes in light-blue and black
to suggest the appearance of enamel
wares, the product for which this
merchant is best known.

Bottom left, for a grain miller:
single-color design with logotype.
Bottom center, for an art school:
black type with accentuated K
("Art" in German is "Kunst"), implying
the search for form and expression.
Bottom right, for an architect:
the sparsely-used elements of space
characterize the architect's activities
in construction and interior design.

69 David. "Psalm 19." 1959. Broad-
side on hand-made paper. Block letters
written with twisted pen to produce
evenness of strokes. Diagonal strokes
are stressed throughout, to emphasize
the presence of the twisted pen.
Original size 24 x 36 cm.

DIE HIMMEL ERZÄHLEN DIE EHRE GOTTES/ UND DIE FESTE VERKÜNDIGT SEINER HÄNDE WERK ▪ EIN TAG SAGT'S DEM

ANDERN/ UND EINE NACHT TUT'S KUND

DER ANDERN · ES IST KEINE SPRACHE NOCH

REDE/ DA MAN NICHT IHRE STIMME HÖRE ·

IHR SCHALL GEHT AUS IN ALLE LANDE UND

IHRE REDE AN DER WELT ENDE ···

DAVID/ PSALM 19/ ISRAEL/ UM 1000 V·CHR·

Friedrich Neugebauer

70/71 *Ludwig van Beethoven. "Heiligenstädter Testament" ("Last Will and Testament"). 1976. Title page and interior page from a hand-written and hand-bound manuscript. Uncial letters written in shell gold with a quill, on purple parchment. Suede binding and leather slip-case. Original size 12.5 x 25 cm.*

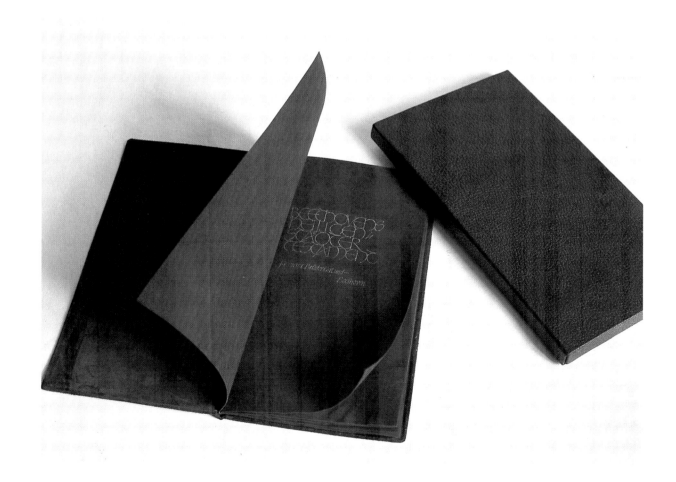

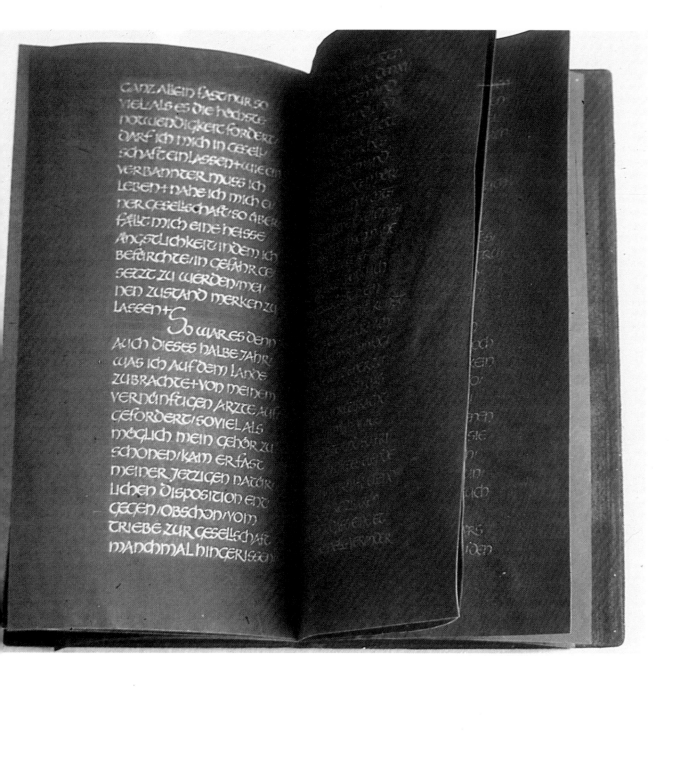

GANZ ALLEIN FAST NUR SO
VIEL ALS ES DIE HÖCHSTE
NOTWENDIGKEIT FORDERT
DARF ICH MICH IN GESELL
SCHAFT EINLASSEN + WIE EIN
VERBANNTER MUSS ICH
LEBEN + NAHE ICH MICH EI
NER GESELLSCHAFT, SO ÜBER
FÄLLT MICH EINE HEISSE
ÄNGSTLICHKEIT, INDEM ICH
BEFÜRCHTE, IN GEFAHR GE
SETZT ZU WERDEN, MEI
NEN ZUSTAND MERKEN ZU
LASSEN +

So war es denn
AUCH DIESES HALBE JAHR,
WAS ICH AUF DEM LANDE
ZUBRACHTE + VON MEINEM
VERNÜNFTIGEN ARZTE AUF
GEFORDERT, SOVIEL ALS
MÖGLICH MEIN GEHÖR ZU
SCHONEN, KAM ER FAST
MEINER JETZIGEN NATÜR
LICHEN DISPOSITION ENT
GEGEN, OBSCHON, VOM
TRIEBE ZUR GESELLSCHAFT
MANCHMAL HINGERISSEN

EINES TAGES
BEGEGNETE DER BÄR DEM
FUCHS, DER MIT EINER MENGE FI-
SCHE DAHERGESCHLENDERT KAM, DIE
ER EBEN GESTOHLEN HATTE. ‹WOHER HAST
DU DIESE ?›FRAGTE DER BÄR. ‹OH, MEISTER
PETZ, ICH BIN FISCHEN GEWESEN UND HABE SIE
GEFANGEN.›DER BÄR ENTSCHLOSS SICH AUF DER
STELLE, AUCH FISCHEN ZU LERNEN, UND BAT
DEN FUCHS, IHM DIESE KUNST BEIZUBRINGEN.
‹ES IST GANZ LEICHT›,ANTWORTETE DER FUCHS,
‹DU BRAUCHST BLOSS AUF DEN ZUGEFRO-
RENEN TEICH HINAUSZUGEHEN, EIN
LOCH IN DAS EIS ZU BRECHEN UND
DEINEN SCHWANZ HINEIN-
ZUSTECKEN·

*Following pages: 73/74/75
Typeface designs*

pater noster

qui es in caelis,
sanctificetur
nomen tuum.
adveniat regnum tuum.
fiat voluntas tua
sicut in caelo
et in terra.
panem nostrum
quotidianum
da nobis hodie.
et dimitte nobis
debita nostra,
sicut et nos
dimittimus,
debitoribus nostris.
et ne nos inducas
in tentationem,
sed libera nos a malo.
amen.

WER NICHT AUS WELTENHÖHEN
NEU GEBOREN WIRD/KANN
NICHT DAS REICH DES GOTTES/
GEISTES SCHAUEN·

Ja so ist es wie ich Dir sage: Wer nicht die Neugeburt
erfährt aus des Wassers Bildkraft und aus dem
Geisteshauch der Luft/kann zu dem Reich des Gottes/
geistes keinen Zugang finden· Was aus dem Erden
dasein geboren wird/ist fährt nur irdischer Natur/
was aber aus dem Atem des Geistes geboren wird/ist
selbst waltender Geist·

a b c d e f g h i j k l m n o p q r s ß
ff s t u v w x y z ff ff m n 1 2 3 4 5 6 7 8 9 0
· ' ' : ! ? · () · A B C D E F f G
H I J K L M N O P Q R S T U
V W X Y Z / - Æ Ö Ü R A T T

F. Neugebauer

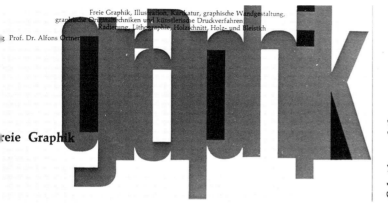

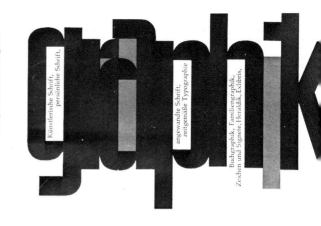

Freie Graphik, Illustration, Karikatur, graphische Wandgestaltung, graphische Originaltechniken und künstlerische Druckverfahren, Radierung, Lithographie, Holzschnitt, Holz- und Bleistich

g Prof. Dr. Alfons Ortner

reie Graphik

Leitung Prof. Friedrich Neugebauer

Schriftgraphik

Künstlerische Schrift, persönliche Schrift,

angewandte Schrift, zeitgemäße Typographie

Buchgraphik, Familiengraphik, Zeichen und Signete, Heraldik, Exlibris,

76 Greeting card. Roman
 numerals printed from
 linoleum block.
 Original size 21.5 x 12.5 cm.

Ein frohes Fest - ein gutes und erfolgreiches Jahr entbietet Dr. Hanns Kreczi, Linz Zaubertal

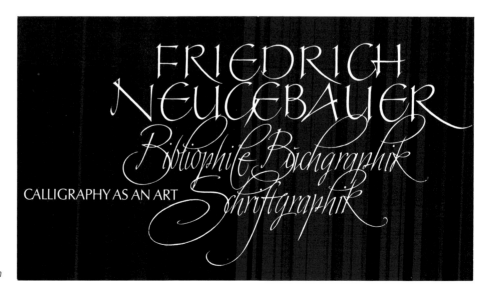

77 Invitation

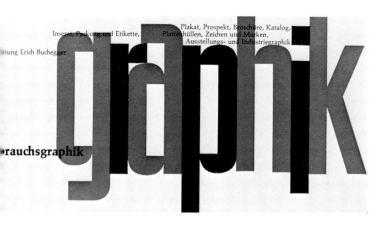

Inserat, Peckung und Etikette, Plakat, Prospekt, Broschüre, Katalog,
 Plattenhüllen, Zeichen und Marken,
 Ausstellungs- und Industriegraphik

...tung Erich Buchegger

graphik

rauchsgraphik

77 Invitation 76 Greeting cards.

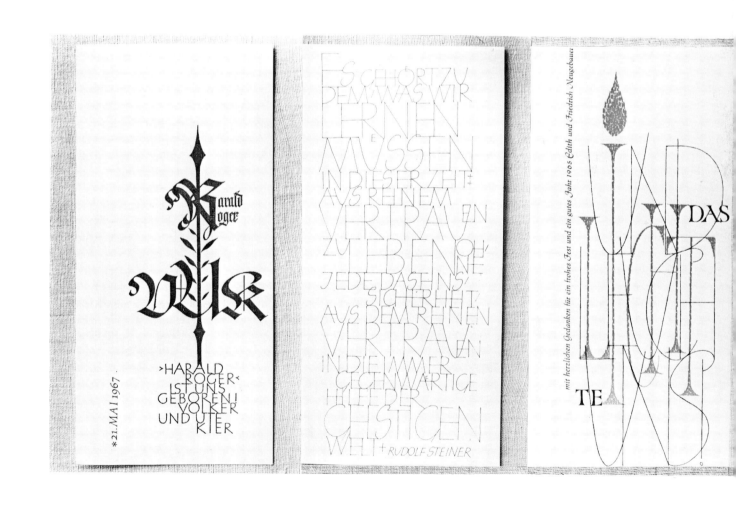

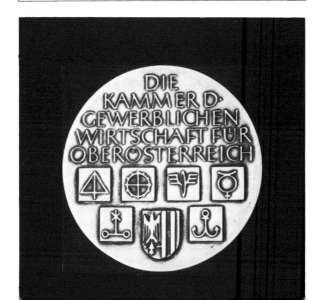

80 *Decorative exterior*
signage for a business.
Made from metal.
Letterhead and card designs.

81 *Newspaper advertisements.*

rosper my way which I go:
Behold, I stand by the fountain
water; and let it come to pass,
: the maiden which cometh forth
raw, to whom I shall say, Give
I pray thee, a little water of thy
her to drink;

And she shall say to me, Both
k thou, and I will also draw for
camels: let the same be the
man whom the LORD hath ap-
ted for my master's son.

And before I had done speaking
mine heart, behold, Rebekah came
with her pitcher on her shoulder;
she went down unto the fountain
drew: and I said unto her, Let
drink, I pray thee.

And she made haste, and let
n her pitcher from her shoulder,
said, Drink, and I will give thy
els drink also: so I drank, and
made the camels drink also.

And I asked her, and said,
ose daughter art thou? And she
: The daughter of Bethuel, Na-
son, whom Milcah bare unto
: and I put the ring upon her
, and the bracelets upon her
a.

And I bowed my head, and
shipped the LORD, and blessed
LORD, the G
aham, which
t way to t
er's daughte
And now if y
truly with m
if not, tell m
e right hand,
Then Laban
red and said,
rom the LORI
thee bad or g
Behold, Rebe
her, and go,
er's son's w
spoken.
And it came t
ham's servant
owed himself
the LORD.
And the serv
ls of silver, s
raiment, an
ekah: he gave
to her mother
And they did
the men that v
ed all night;
morning, and
unto my ma
And her broth
Let the dam
w days, at th
she shall go.
And he said,
ot, seeing the
my way; se
go to my mas
And they said
el, and inquire at her mouth.

And they called Rebekah, and
unto her, Wilt thou go with this
And she said, I will go.

And they sent away Rebekah
sister, and her nurse, and
ham's servant, and his men.

And they blessed Rebekah, and
nto her, Our sister, be thou *the*
er of thousands of ten thousands,
et thy seed possess the gate of
which hate them.

And Rebekah arose, and her
els, and they rode upon the
, and followed the man. and
took Rebekah, and went
ay.

nd Isaac came from the way of
-lahai-roi; for he dwelt in the
of the South.

nd Isaac went out to meditate
field at the eventide: and he
up his eyes, and saw, and,
d, there were camels coming.

nd Rebekah lifted up her eyes,
when she saw Isaac, she lighted
e camel.

nd she said unto the servant,
t man is this that walketh in the
to meet us? And the servant
It is my master: and she took
il, and covered herself.

nd the servant told Isaac all the
that he had done.

8 Now therefore, my son, obey my
voice according to that which I com-
mand thee.

9 Go now to the flock, and fetch me
from thence two good kids of the
goats; and I will make them savoury
meat for thy father, such as he loveth:

10 And thou shalt bring it to thy
father, that he may eat, so that he
may bless thee before his death.

11 And Jacob said to Rebekah his
mother, Behold, Esau my brother is
a hairy man, and I am a smooth man.

12 My father peradventure will feel
me, and I shall seem to him as a
deceiver; and I shall bring a curse
upon me, and not a blessing.

13 And his mother said unto him,
Upon me be thy curse, my son: only
obey my voice, and go fetch me them.

14 And he went, and fetched, and
brought them to his mother: and his
mother made savoury meat, such as
his father loved.

15 And Rebekah took the goodly
raiment of Esau her elder son, which
were with her in the house, and put
them upon Jacob her younger son:

16 And she put the skins of the kids
of the goats upon his hands, and upon
the smooth of his neck:

17 And she gave the savoury meat

bear upon my knees, and I also may
obtain children by her.

And she gave him Bilhah her

the daughters will call me happy: and
she called his name Asher.

14 And Reuben went in the days of
wheat harvest, and found mandrakes
brought them unto
Then Rachel said
I pray thee, of thy
unto her, Is it a
thou hast taken
d? and wouldest
y son's mandrakes
l said, Therefore
ee to-night for thy
e from the field in
Leah went out to
l, Thou must come
have surely hired
mandrakes. And
t night.
rkened unto Leah,
and bare Jacob a
d, God hath given
e I gave my hand-
nd: and she called
Jacob.
ceived again, and
Jacob.
d, God hath en-
good dowry; now
well with me, be-
him six sons: and
Zebulun.
rds she bare a
d her name Dinah.
membered Rachel,
ned to her, and
ceived, and bare a
d hath taken away

24 And she called his name Joseph,
saying, The LORD add to me another
son.

25 ¶ And it came to pass, when
Rachel had borne Joseph, that Jacob
said unto Laban, Send me away, that
I may go unto mine own place, and
to my country.

26 Give me my wives and my children

ther Esau, and moreover he cometh
to meet thee, and four hundred men

thee good, and make thy seed as the
sand of the sea, which cannot be
numbered for multitude.

13 And he lodged there that night;
and took of that which he had with
him a present for Esau his brother;

14 Two hundred she-goats and twen-
ty he-goats, two hundred ewes and
twenty rams,

15 Thirty milch camels and their colts,
forty kine and ten bulls, twenty she-

vailed not against him, he touched
the hollow of his thigh; and the
hollow of Jacob's thigh was strained,
as he wrestled with him.

26 And he said, Let me go, for the
day breaketh. And he said, I will
not let thee go, except thou bless me.

27 And he said unto him, What is
thy name? And he said, Jacob.

28 And he said, Thy name shall be
called no more Jacob, but Israel: for
thou hast striven with God and with
men, and hast prevailed.

29 And Jacob asked him, and said,
Tell me, I pray thee, thy name. And
he said, Wherefore is it that thou dost
ask after my name? And he blessed
him there.

30 And Jacob called the name of the
place Peniel: for, *said he*, I have seen
God face to face, and my life is pre-
served.

31 And the sun rose upon him as he
passed over Penuel, and he halted
upon his thigh.

twelve:

23 The sons of Leah; Reuben,

ters of Canaan; Adah the daugh
of Elon the Hittite, and Oholibam
the daughter of Anah, the daught
of Zibeon the Hivite;

3 And Basemath Ishmael's daught
sister of Nebaioth.

4 And Adah bare to Esau Elipha
and Basemath bare Reuel.

5 And Oholibamah bare Jeush, a
Jalam, and Korah: these are the so
of Esau, which were born unto h
in the land of Canaan.

6 And Esau took his wives, and
sons, and his daughters, and all t
souls of his house, and his cattle, a
all his beasts, and all his possessio
which he had gathered in the land
Canaan; and went into a land a
from his brother Jacob.

7 For their substance was too gr
for them to dwell together; and t
land of their sojournings could n
bear them because of their cattle.

8 And Esau dwelt in mount Se
Esau is Edom.

9 And these are the generations
Esau the father of the Edomites
mount Seir:

10 These are the names of Esa
sons; Eliphaz the son of Adah t
wife of Esau, Reuel the son of Ba
math the wife of Esau.

11 And the sons of Eliphaz we
Teman, Omar, Zepho, and Gata
and Kenaz.

12 And Timna was concubine
Eliphaz Esau's son; and she bare
Eliphaz Amalek: these are the so
of Adah Esau's wife.

13 And these are the sons of Reu
Nahath, and Zerah, Shammah, a
Mizzah: these were the sons of Ba
math Esau's wife.

14 And these were the sons of Oho
bamah the daughter of Anah, t
daughter of Zibeon, Esau's wife: a
she bare to Esau Jeush, and Jala
and Korah.

15 These are the dukes of the so
of Esau: the sons of Eliphaz t
firstborn of Esau; duke Teman, du
Omar, duke Zepho, duke Kenaz,

16 Duke Korah, duke Gatam, du
Amalek: these are the dukes th
came of Eliphaz in the land of Edo
these are the sons of Adah.

17 And these are the sons of Reu
Esau's son; duke Nahath, duke Ze
rah, duke Shammah, duke Mizza
these are the dukes that came
Reuel in the land of Edom; these a
the sons of Basemath Esau's wife.

18 And these are the sons of Oho
bamah Esau's wife; duke Jeush, du
Jalam, duke Korah: these are t
dukes that came of Oholibamah t
daughter of Anah, Esau's wife.

19 These are the sons of Esau, a
these are their dukes: the same is Edo

20 ¶ These are the sons of Seir t
Horite, the inhabitants of the lan
Lotan and Shobal and Zibeon a
Anah,

21 And Dishon and Ezer and Disha
these are the dukes that came of th
Horites, the children of Seir in t
land of Edom.

And the children of Lotan we

the smell of my son is as the smell of
a field which the LORD hath blessed:

28 And God give thee of the dew of
heaven, and of the fatness of the
earth, and plenty of corn and wine:

29 Let peoples serve thee, and na-
tions bow down to thee: be lord over
thy brethren, and let thy mother's
sons bow down to thee: cursed be

hath taken venison, and brought it
me, and I have eaten of all before
thou camest, and have blessed him?
yea, *and* he shall be blessed.

34 When Esau heard the words of
his father, he cried with an exceeding
great and bitter cry, and said unto

31 And he said, What shall I give
thee? And Jacob said, Thou shalt
not give me aught: if thou wilt do
this thing for me, I will again feed
thy flock and keep it.

32 I will pass through all thy flock
to-day, removing from thence every

Laudate et benedicite mi signore et rengraciate.
Lobet und preiset meinen Herrn und danket
et servite serviteli cum grande humilitade·
und dienet dienend in großer Demut·

ΟΣΟΙ ΔΕ ΕΛΑΒΟΝ ΑΥΤΟΝ,
 ΕΔΩΚΕΝ ΑΥΤΟΙΣ ΕΞΟΥΣΙΑΝ
ΤΕΚΝΑ ΘΕΟΥ ΓΕΝΕΣΘΑΙ,
ΤΟΙΣ ΠΙΣΤΕΥΟΥΣΙΝ ΕΙΣ ΤΟ ΟΝΟΜΑ ΑΥΤΟΥ,

ALLEN ABER/DIE ES AUFNAHMEN/
 GAB ES MACHT/
KINDER GOTTES ZU WERDEN/
DENEN/DIE AN SEINEN NAMEN GLAUBEN/

Ernst Degasperi - Friedrich Neugebauer
Sonnengesang des hl. Franziskus
Verlag der Neugebauer Preß Bad Goisern

82 Top: *"Sonnengesang des hl. Franziskus" ("Sun Hymns of St. Francis"). 1974. Illustrations by Ernst Degasperi. Double page with Latin text in Roman minuscule and German text in contrasting Gothic overtones, both written with angled pen. Text designed and positioned to complement illustration. Black lettering with multi-colored illustration. From the "Graphik Studio" series. Original size 35 x 35 cm.*
Bottom: "Prolog nach Johannes" ("Gospel According to John"). 1974. Illustration by Ernst Degasperi. Double page with Roman caps for both Greek and German text, written with flat pen. Text position complements illustration. Green lettering with multi-colored illustration. From the "Graphik Studio" series. Original size 35 x 35 cm.

83 *"Sonnengesang." Title page. Uncials arranged in a circle, with contrasting titles in narrow Roman, both written with angled pen. Original size 35 x 35 cm.*

ALOIS
WEYWAR

ORGA
NISCHE
BEWE
GUNG

Einführung in Dr. Thun-Hohenstein's
geistiges Erbe

Neugebauer

ABCDE
FGHIJK
LMTQP
RNSUV
WXYZ·!
?12345

85/86 Working drawings
for letters to be cut
into stone or wood.

abcdeh
gfijklm
nopqrs
tuvwyx
zAntiqua
67890

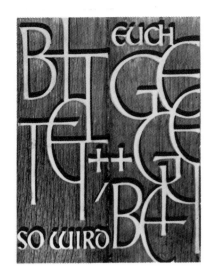

87 Wall inscriptions for churches. Original lettering done in Uncial with flat pen, then formed in brass and covered with gold leaf. Mounted on oak panels. Sizes 60 x 30 cm, 35 x 30 cm, 24 x 30 cm.

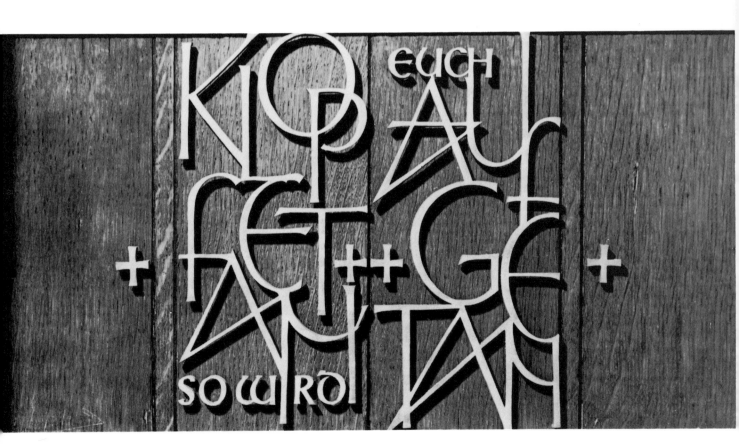

88 Josef Weinheber. "Ode an die Buchstaben" ("Ode to Letters"). 1962. Graphic wall designed for a school. Lettering put onto ceramic plaques with flat brush and then baked. Text is black and initials are gold. Original size 700 x 300 cm.

89 *Georg Matthaus Fischer. Quotation about life and salt trade in 17th century Austria. 1978. Graphic wall designed for a bank. 36 brass plates etched for differing times to obtain variations in tone. Uncial lettering was applied in asphalt with a brush, prior to etching, and later removed to expose shiny, unetched letters. Original size 300 x 300 cm.*

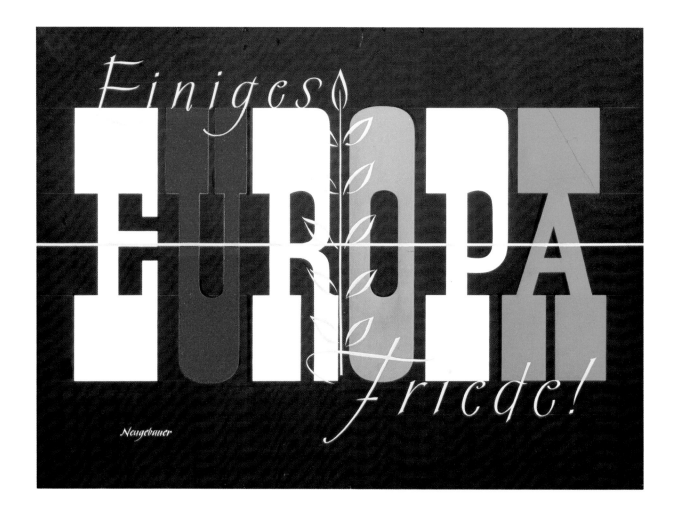

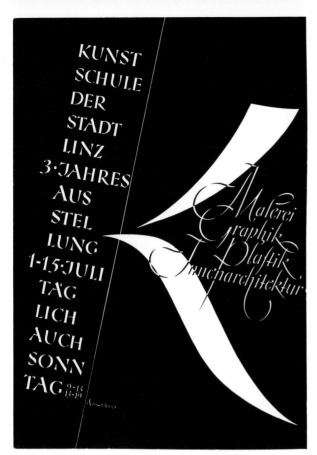

KUNST
SCHULE
DER
STADT
LINZ
3·JAHRES
AUS
STEL
LUNG
1-15·JULI
TÄG
LICH
AUCH
SONN
TAG 9-13
13-19

Malerei
Graphik
Plastik
Innenarchitektur

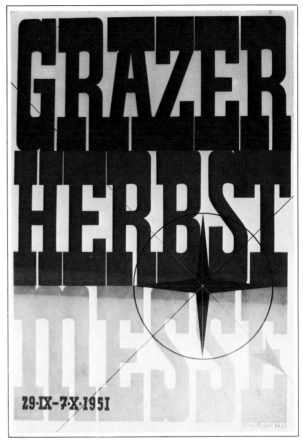

GRAZER
HERBST
MESSE
29·IX-7·X·1951

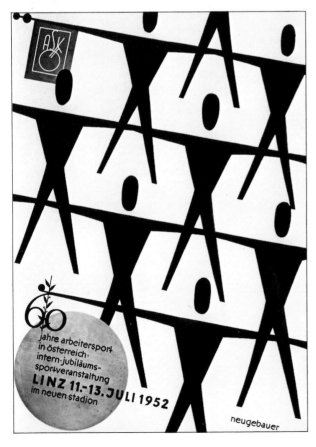

60
jahre arbeitersport
in österreich.
intern.jubiläums-
sport-veranstaltung
LINZ 11.-13. JULI 1952
im neuen stadion

neugebauer

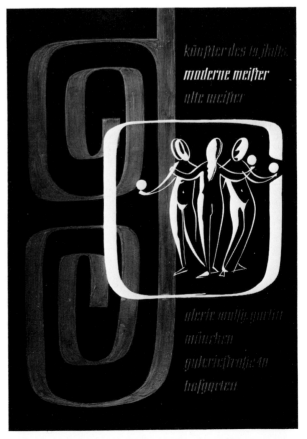

künstler des 19.jahrh.
moderne meister
alte meister

galerie wolfg.gurlitt
münchen
galeriestraße 4a
hofgarten

This volume of lessons and thoughts comes primarily as a response to the many requests that I received from visitors to the exhibitions of my work, and from the students in my classes in Austria and the United States.

The book is a statement of my loyalty and adherence to the instruction—and the text book—of the two masters who first opened up my heart and eyes, and kindled all my enthusiasm for this art: Rudolf von Larisch and Herta von Larisch-Ramsauer. There may be a new aspect here and there, a new awareness, perhaps a new direction leading beyond the heritage that I received, but these things broaden the faith and keep it alive. Through that legacy I was given many precious hours of personal and professional fulfillment, and I would like to offer this book as evidence of those times.

Here are Larisch's thoughts, which cast such a spell over me: "Dedication to noble lettering and books is the bond that unites us. Anyone who becomes part of this fellowship gets no external proof of belonging and must simply feel and know it in his heart. High-quality lettering and strong design are prerequisites. People are only members if they feel fulfillment when they are lettering, and are committed to noble efforts in the book arts. As a result of this dedication, the clamor and impure motivations of everyday life cannot penetrate our midst.

We desire the presence of our innermost beliefs in all that we do, and wish to keep them unspoiled. May our fellowship help to fulfill this longing . . .".

R. L.

May your involvement with lettering and its uses give you pleasure and satisfaction, and may you succeed through your work in supporting others to defend and propagate truth, good and beauty! "Get on with it!" Friends and support will be present along the way. The greatest support for me came from Larisch's textbook, "Unterricht in ornamentaler Schrift," and from Edward Johnston's "Writing & Illuminating & Lettering," where I found many hints about materials and techniques. And now, enjoy yourself!

138

Within some knowledgeable circles there resides a belief that every art consists of approximately nine parts plagiarism to one part artistic creativity and interpretation. At first blush that assessment appears handsomely generous to calligraphers, who, after all, must be obedient to a prescription of recognizable letterforms and respectful of the historical alphabets. Indeed many contemporary Anglo-American scribes seem reluctant to exercise the full extent of their share in the creative process. By their lights, rules, traditions and correctness are touchstones of awful weight. Innovations seldom receive immediate smiles, and excellence is measured by fidelity to certain esteemed precedents. Consequently, their calligraphy is often cloaked in a safe, correct and faintly anachronistic orthodoxy. By and large, European calligraphers have tended to more adventuresome letterforms and graphic designs. No doubt, rules and traditions apply on the continent also, but one gets the impression that offenders are not zealously prosecuted there.

It is an open and shut case that the teaching and practice of modern calligraphy in Europe differ significantly from those in America and England. However, literature by the masters themselves to explain these differences has been scarce. Even so influential a book as Rudolf von Larisch's "Unterricht in ornamentaler Schrift" has not been published in English. Therefore this translation of Friedrich Neugebauer's book is doubly welcome. Besides being a richly reproduced collection of his work, it provides a rare insight into the reasons why his lettering and designs—and that of many other European scribes— are so idiosyncratic and still responsive to the highest goals of the art.

The key to Neugebauer's style is the conspicuousness of his involvement with the text. The typical American or English scribe ordinarily writes out the text in an alphabet he has in stock. Often the selected hand is appropriate and written with great skill. Despite minor modifications and embellishments, however, it remains essentially a stock item and seldom reveals the intensity of feeling the scribe may have had for the text. Neugebauer's approach, on the other hand, is suggestive of the Chinese calligrapher. Texture and form arise out of the inner meaning of the text. His intention is that, at any future date, the reader will clearly recognize the depth of his involvement with the text. The result is an intensely personal style of remarkable versatility. Thus the student who reads this book with an eye towards writing exactly like Neugebauer may be wasting vitamins on a pointless ambition. The real and worthwhile prize is an opportunity to develop an expressive and uncontrived lettering style of your own. That is what the adventure in calligraphy is about.

Don Moy

Curriculum Vita

1911 *Friedrich Neugebauer, born 16 November 1911 in Kojetein, Mahren (now part of Czechoslovakia).*

1921–1930 *Elementary school and apprenticeship as lithographer in Troppau, Austria.*

1930–1932 *First study of lettering and book design under Professor Paul Hampel at the Kunstgewerbeschule in Breslau.*

1932–1935 *Intensive study at the Kunstgewerbeschule of the Austrian Museums for Art and Industry, Vienna. Studied lettering with Professor Rudolf v. Larisch, architecture with Professor Oskar Strnad, and painting with Professor Wilhelm Müller-Hoffman.*

1935–1939 *Free-lance design in Vienna. Collaboration with various Austrian and foreign publishers.*

1936 *Assistant to Professor Herta Larisch-Ramsauer at the Kunstgewerbeschule, Vienna.*

1937 *Diplome d'honneur and gold medal, World Exposition, Paris, in the category, "Illustrations, Livres d'Art Illustrés."*

1940–1944 *Military service in France, Poland, Russia and Italy.*

1944–1947 *Prisoner-of-war in Egypt.*

1947 *Free-lance design in Bad Goisern, Austria.*

1949–1951 *Honorary instructor at the City Art School, Linz, Austria.*

1951–1973 *Leader, Master Class for Lettering and Applied Graphic Design, City Art School, Linz.*

1961 *Appointed as Full Professor*

1963 *Founding of the Neugebauer Press, Bad Goisern.*

1964 *Founding of a shop for lovers of books and graphics, Bad Goisern.*

1973–present *Leader, Master Class for Lettering and Book Design, Hochschule für künstlerische und industrielle Gestaltung, Linz.*

Exhibitions: Berlin, Bologna, Dublin, Düsseldorf, Edinburgh, Frankfurt am Main, Linz, London, Munich, Paris, Offenbach, Rome, Stockholm, Warsaw, Vienna, Boston, Cambridge, Los Angeles, Providence, San Francisco.

Awards for lettering and design: London, Paris, Trieste 1962, Trieste 1965, Rome, Stockholm, Vienna (Gold Medal).

Awards for publishing house: 6 Federal Prizes in Austria, numerous medallions and citations from Austria and abroad.

Translator's Note

Throughout the captions in the book, you will find English translations in parentheses. These are my own interpretations of the German titles and may conflict with existing translations; my intent was merely to provide some extra insights for those readers who do not know German.

My deepest thanks to Michael Neugebauer and Walter Hager for their important contributions to the translation; I could not have completed this project without them.

Thanks also to Paula Carroll, Walter Grossman, Nora Jennings, Don Moy and Louis Strick for their help and advice along the way.

Copyright © 1979, Verlag Neugebauer Press, Salzburg, Austria; Original title:
"Kalligraphie als Erlebnis, Baugesetze der Schrift—Schule des Schreibens."
Copyright © 1980, English text, Neugebauer Press USA Inc.
Published in USA by Neugebauer Press USA Inc.,
Distributed by Alphabet Press, Natick, MA.
Distributed in Canada by Grolier Ltd., Toronto.
Published in UK by Neugebauer Press Publishing Ltd.,
Distributed by A & C Black, London.
Second hardcover edition, first softcover edition.
ISBN 0-907234-00-3 hardcover.
ISBN 0-907234 50 X softcover.
All rights reserved.

Design, calligraphy and typography by Friedrich Neugebauer.
Typesetting by Berkeley Typographers, Boston.
Set in Optima and Optima italic designed by Hermann Zapf.
Color separations by F. Krammer, Linz.
Offset printing by Druckhaus Nonntal, Salzburg.
Binding by Ecobinder, Salzburg.

Printed in Austria